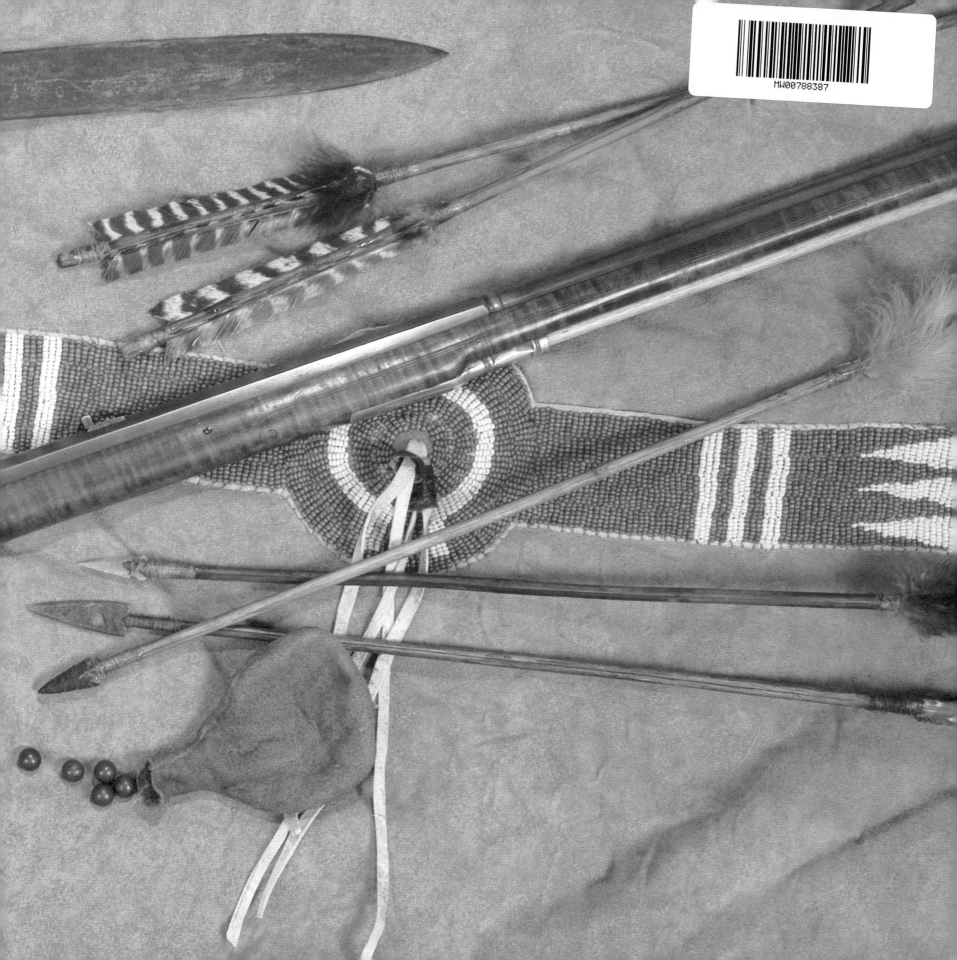

THE COMPLETE COLLECTION

CHARLES FRITZ

100 Paintings

Illustrating the Journals

of Lewis and Clark

Charles Fritz

by Charles Fritz

FARCOUNTRY
PRESS

Helena, Montana

Dedicated to

Joan Fritz,
whose loving support has never wavered and
whose daily contributions are beyond measure,

and to

Tim Peterson,
whose generosity, foresight, and vision for this collection
are a gift to us all.

Regular Edition
ISBN 10: 1-56037-446-2
ISBN 13: 978-1-56037-446-6

Limited Edition
ISBN 10: 1-56037-489-6
ISBN 13: 978-1-56037-489-3

© 2009 by Farcountry Press
Artwork and text © 2009 by Charles Fritz

Cover image: "The Arrival of Captain Lewis at the Great Falls of the
Missouri—June 13, 1805"

For more information on our books, write Farcountry Press, P.O. Box 5630,
Helena, MT 59604; call (800) 821-3874; or visit www.farcountrypress.com.

Library of Congress Cataloging-in-Publication Data

Fritz, Charles, 1955-
 Charles Fritz : 100 paintings illustrating the Lewis and Clark journals :
the complete collection / by Charles Fritz.
 p. cm.
 Includes index.
 ISBN 978-1-56037-446-6
 1. Lewis and Clark Expedition (1804-1806)--Pictorial works. 2. West
(U.S.)--Discovery and exploration--Pictorial works. 3. Explorers--West
(U.S.)--History--19th century--Pictorial works. 4. Frontier and pioneer
life--West (U.S.)--Pictorial works. 5. Fritz, Charles, 1955- 6.
Painters--Iowa--Biography. 7. Painting, American. I. Title.
 F592.7.F74 2009
 759.13--dc22
 2008048865

Created, produced, and designed in the United States.
Printed in China.

15 14 13 12 11 10 09 1 2 3 4 5 6 7

Table of Contents

Acknowledgments

In order for the Corps of Discovery to reach the Pacific Ocean, the men had to lean into the wind, dip their paddles, and strain against the current thousands of times. The French voyageurs who initially went along with the Lewis and Clark Expedition would have called the head boatman the "patron," and the paddlers were the "milieu." During the production of the paintings over the last ten years, many people have picked up a paddle and helped move this project forward. Some have steadfastly paddled every day, and this patron knew he could always count on them. And others, when asked to lend their special talents or knowledge, were always quick to grasp the paddle handed to them. I have looked forward to the day when I could acknowledge these generous people. Their contributions to this book and to the success of the collection are greatly appreciated. Like relationships forged out on the trail under adversity, my gratitude for their help runs deep. I extend the warmest of thanks to:

Tim, Elaine, Leigh, and Henry Peterson, for recognizing the value of this collection and for preserving it for future generations. Tim's thoughtful insights and generous support have improved and expanded the collection.

Joan Fritz, for her daily help, guidance, and support through every trial and triumph; and Isaac and Erik, who were always willing to help and are the finest of companions on any trail.

The late Bob Scriver, for his friendship and for his critical role in the collection's creation.

Wayne York, for his counsel, help, and support.

Kathy Springmeyer, Jessica Solberg, and Shirley Machonis of Farcountry Press, for their guidance and expertise during the editing, designing, and publication of this book.

The late Stephen Ambrose, for his time and knowledge in the early stages of this project.

Stephenie Ambrose-Tubbs, for her assistance in editing captions.

Gary Moulton and the University of Nebraska Press, for allowing us to use the quotes from the Moulton edition of the Lewis and Clark Journals.

Byron Price, director, Charles M. Russell Center, for his support and sustained interest throughout the production of the collection.

Darlene Rieter and Carey Matovich, for their contributions to the success of the collection.

Bob Brown of Cody, Wyoming, for his commitment to the success of the exhibition.

Dan Tilton of Photographic Solutions, and Mick McMillan of McMillan Photographic Studios for their meticulous work in photographing the paintings.

Pat Hagan, for his many design contributions during the production of exhibition materials.

Bruce Eldridge, executive director, Buffalo Bill Historical Center; Mindy Besaw, curator; Wally Reber, exhibitions designer; Lee Haines, director of public relations; Elizabeth Holmes, registrar; Anne Marie Donoghue, registrar; Kimber Swenson, art director; and to the many staff members of the Buffalo Bill Historical Center, whose expertise has benefited the 2009 exhibition.

George Dennison, Robert Frazier, Maggie Mudd, Barbara Koostra, Manuella Well-Off-Man, Caroline Peters, Bill Queen, Harry Fritz, David Purviance, Joy Ott, Patrice Elliott, John Peirce, Charles Schroeder, Ed Muno, Anne Morand, Seth Hopkins, Robert Knight, Robyn Peterson, Sheila Perry, and Traci Bittner, whose expertise helped to make the bicentennial tour from 2003 to 2006 such a success.

Peter and Noydena Brix; John Cullinan; Joyce and the late Joel Hanes; Gareld and Barbara Krieg; Jess and Jean Ladow; Jon and Dot Oscher; the late Butch Ott; Dave and Sandy Solberg; George and Linda Steiner; Rick and Sarah Stevenson; and Tim and Annie Thom, for the special roles they played during the exhibition's bicentennial tour from 2003 to 2006.

Robert Moore, Bud Clark, Bob Anderson, Bryant Boswell, Alan Chronister, Gary Leppart, Don Peterson, Larry Epstein, Gene Hickman, Ron Ukranitz, Joe Musselman, Jeff Walker, and James Denny, for their valuable assistance with historical accuracy.

And my models: Walt Martin; Doug Epperly; the Broyles brothers—Paul, Mark and John; Allen Sasser-Goehner; Allison Haux; Paul Taylor; Siedel Standing Elk; K. T. Monson; Ron Garritson; T. J. Lynde; Isaac Fritz; Mark Duffy, Lucas Stutzer; the members of the Discovery Corps of St. Charles; and the Lewis and Clark Honor Guard of Great Falls.

Foreword

by Timothy Peterson

As a young boy growing up in the Midwest, I loved the outdoors—particularly hunting and fishing with my father and brother. I often dreamt of being an explorer as my friends and I embarked on canoe trips and day trips into the woods on the outskirts of town. Maybe it was this fascination with adventure that led to my adult interest in collecting Western art, particularly that focusing on nineteenth-century trappers and mountain men. I am especially drawn to artwork depicting Lewis and Clark's almost unbelievable epic journey through the uncharted Louisiana Territory from 1804 to 1806.

As I read more about Lewis and Clark and the Corps of Discovery, particularly their compelling Journals, I came to realize that the Expedition not only broadened the boundaries of the United States but told a timeless, human story of success, failure, hardship, bounty, fear, and joy. The Corps faced challenges with resolve, determination, and loyalty, which I found absolutely inspiring. As I did more and more reading about the Expedition, it became clear that although there are numerous books on the subject, there are few works of art focusing on these remarkable historical figures and their achievements. The adventurer in me wanted not only to read about the Corps's remarkable travels into the unknown but to see what they saw—take in the breathtaking scenery, meet the various Native American tribes, and see the new plant and animal species they encountered.

Imagine my joy when, in 2004, I heard that the highly respected Western artist Charles Fritz was developing a collection of paintings based on entries from the Lewis and Clark Journals. I contacted Charles and learned he was collaborating with the University of Montana to tour an exhibition of seventy-two paintings, consisting of both small studies and larger finished works. The exhibition was to travel to seven museums across the United States to celebrate the Lewis and Clark Expedition Bicentennial. After the tour was over, he planned to sell the paintings individually. I communicated my interest in purchasing some of the pieces and asked Charles to let me know when that opportunity might occur. As I heard more of Charles's ideas and got caught up in his enthusiasm, my interest in his project began to grow. During

one of our phone conversations, Charles told me of his increasing desire to see the collection stay together. I became immediately interested in helping him reach that goal. It was now the spring of 2005. The collection of paintings was at the National Cowboy and Western Heritage Museum in Oklahoma City, Oklahoma. Charles and I agreed to meet there for the first time. And thus our own journey together began.

We discovered we had grown up only a couple of hours apart (I in Rochester, Minnesota, and he in Mason City, Iowa), had similar interests in the outdoors, and had strong family backgrounds rooted in education and faith. We also found out that we liked many of the same Western artists, including Maynard Dixon, Robert Lougheed, and Bob Scriver. We spoke of his relationships with the University of Montana and Stephen Ambrose and how the idea for this project had begun. I shared with Charles my thoughts on the collection and why I, too, felt the pieces needed to be kept together. I felt this collection was an important new contribution to our understanding of American history, one that allowed people to see and experience an event that helped define the United States we live in today. Charles and I agreed; the paintings should stay together. Our common vision determined, I agreed to purchase the entire collection if Charles would agree to expand it to 100 paintings. This broadened collection would comprehensively illustrate the entire journey from start to finish by visually examining many crucial elements and events that took place during those two-and-a-half years.

As Charles painstakingly researched each of the paintings in order to ensure their historical accuracy, we talked almost daily about the works and how to create the most engaging, educational, and informative Lewis and Clark experience—what new stories to tell, how to make the collection flow with energy, depth, and color. The result of Charles Fritz's ten years of dedication—in which he drove thousands of miles to paint the exact locations described in the Journals in the proper season—is a beautiful body of work, a valuable historical and artistic treasure. I know of no other artist today who would dedicate a decade to research subjects, travel thousands of miles to paint on-site in the correct season, and be willing to forego other economic opportunities as Charles did for this collection of paintings.

Over the course of this project, Charles and I have worked together in a very Lewis-and-Clark fashion—pursuing a common goal and maintaining a respect, trust, and friendship that has led us to the completion of our journey. I hope you find this book and the paintings herein as engaging and educational as I have. Enjoy your journey with the Corps of Discovery! ॐ

Introduction

It was September 1986, but the days were already cold and the nights colder in northern Alberta, Canada, where I was painting. By wiring a piece of cardboard to the radiator of my 1974 Chevy Suburban, I was able to use the truck's heater to keep the green vinyl seats reasonably warm and pliable. After painting outside all day, I would crawl into the back of the truck and, from inside my sleeping bag, heat a can of soup on my backpack stove. It was impossible to keep cold air from seeping into the truck; it wasn't built to be used as a camper. However, the combination of fatigue and the stove's warmth allowed sleep to come easily. With good weather and Canada's wild beauty to depict, I had produced enough small field studies—from as far north as Maligne Lake—to fill the slotted pine boxes I'd made and coated with spar varnish. Sightings of bighorn sheep, mountain goats, and caribou had already made the trip worthwhile, but a memorable event of even greater meaning was still to come.

Initially, grey skies and a day of drizzle disguised the arrival of the equinox storm; but on the second day, drizzle turned to snow as the storm matured into the first blizzard of the year and laid claim to the entire region with a blanket of white two feet deep. The remote Kananaskis Road at the base of the Rocky Mountain Front was my escape route south, and for hours I traveled without seeing another vehicle in that silent world of swirling white.

As I drove through the snowstorm, I recalled a fellow artist's encouragement that I meet renowned sculptor Bob Scriver, who had lived his entire life on the Blackfeet Reservation in Browning, Montana. Crossing the border back into the United States and finally escaping the southern edge of the storm, I decided I would head for Browning and look him up. Like the hibernating grizzlies in nearby Glacier National Park, the summer tourists had retreated to their warm homes in more hospitable parts of the country. Except for gas station banners flapping relentlessly in the tormenting wind, the main street of Browning was otherwise empty and quiet. Having become accustomed to the constant drone of my truck's engine, I was almost surprised by the sudden silence when I turned off the key. Looking

out through my windshield, framed with snow and ice, I saw a dated building with a sign that read BOB SCRIVER'S HALL OF BRONZE.

Bob Scriver, then seventy-two years old, had become an institution in Montana and in Western art circles. His talent had earned him many honors, including membership in Cowboy Artists of America. Prominent museums purchased his work, and his heroic-sized bronzes appeared throughout the Rocky Mountain West. He had written three books and had been featured on a segment of the 1960s TV show *To Tell the Truth*. Bob Scriver was a complex man whose boundless energy had served him well. He was endlessly curious about a multitude of subjects. An avid student of the natural world, Western history, and the Blackfeet people, he reveled in art depicting these subjects.

It was clear as I ascended the stone steps to the entrance that I was entering a creative person's bailiwick; the steps' flat stones, probably gathered from a nearby outcropping, were held in place by mortar coarser than usual and probably hand mixed in a wheelbarrow. As I entered the building that hadn't changed since the 1950s, I saw turquoise floor tiles and plywood display fixtures made and painted by Bob. Everywhere, there were signs of his industry. Mounted animals peered at me through the dim lighting of one room, and in another I saw bronzes of all sizes and subjects. To encourage sales he had created a studio space where visitors could lean over a half-door and watch him sculpt in clay.

There he was, at work in his studio. I leaned over the half-door and attempted to distinguish myself from the average tourist by giving him, one by one, my reasons for showing up in his studio on this particularly wintry day. Seemingly unimpressed by everything I'd said, he responded with low grunts, which appeared to me to be directed more to the sculpture than to my attempts at conversation. Pressing on, I finally sparked his attention when I mentioned the name of our shared friend. Now looking up from his work, he began to question me; after learning of our common interests, and of my dedication to painting on location, he took a marked interest in my work. Before the morning was over, he was on his hands and knees examining and offering to purchase some of my field studies that, at his request, I had propped up around the floor of the room. He and his wife, Lorraine, invited me to stay for another day so that he could show me their ranch just west of Browning. In subsequent years, the Flat Iron Ranch became my base for many painting trips to Glacier country. My friend Bob Scriver would be the first of three men to play an instrumental role in the creation of this collection of paintings.

In 1998 Bob received a phone call from one of his clients, Wayne York. Then living in Baton Rouge, Louisiana, Mr. York had been raised in the small eastern Montana town of Sydney, located at the confluence of the Missouri and Yellowstone Rivers. Growing up in the shadow of Fort Union, the famous fur trading post, he had cultivated an interest in Lewis and Clark and Western history and eventually purchased some of Bob Scriver's magnificent bronzes. Inspired by Captain Meriwether Lewis's 1805 entry in the Journals detailing the Corps of Discovery's arrival in the Yellowstone valley, Mr. York wanted to commission a painting based on Lewis's description. He contacted Bob for a referral. Mr. York followed Bob's recommendation to call me in Billings, and, intrigued by the concept, I agreed to the commission. Before he could see the finished work, Bob passed away. In the fourteen years I had known Bob, he remained an inspiration and a valued friend who encouraged me in every way.

While working on Mr. York's painting (titled "Captain Lewis Sighting the Yellowstone—April 25, 1805") in 1998, I became aware that, unlike most expeditions that followed, the Lewis and Clark Expedition did not have an artist with them— a remarkable oversight considering how thoroughly President Jefferson and Captain Lewis had applied themselves to this endeavor. I was on a remote bluff overlooking the Missouri River, working on Mr. York's painting, when it occurred to me to create a group of paintings illustrating the Journals.

I could easily imagine the excitement an artist would have felt traveling with the Expedition: the thrill of rounding a bend in the river and seeing the evening sunlight bathing a strange new landscape in warm light, creating the perfect organization of shadows, shapes, and colors; and the marvelous spectacle of witnessing indigenous cultures whose own spirituality and artistry was woven into every item they wore and used in their daily lives. For a painter, there is that initial moment of inspiration that says, "You have to paint that!" That inspiration has to be strong enough to sustain creativity for hours, days, or months. An artist with the Corps would have had more inspiration than he or she had time; and I could empathize, as to this day I remain in awe of the incredible landscapes traversed by the Expedition.

In the more than 200 years since, four men have edited the Lewis and Clark Journals: Nicholas Biddle, Elliott Coues, Reuben Thwaites, and Gary Moulton. Biddle began his work in 1809 and finished five years later. Elliott Coues produced a second edition in the late 1800s, and Reuben Thwaites contributed his edition for

the centennial celebration in 1904. The Thwaites edition was highly regarded and used by scholars for decades, but with our increasing body of knowledge in science and linguistics, it was becoming increasingly clear that an updated edition of the Journals would soon be needed. In 1983, in preparation for the Lewis and Clark Expedition Bicentennial in 2003, Gary Moulton and the Center for Great Plains Studies at the University of Nebraska began producing an edition of twelve volumes with magnificent editing, updating, and footnoting. This remarkable resource was absolutely invaluable in my research for what I came to realize was the first attempt to comprehensively illustrate the Lewis and Clark Journals.

Through the efforts of Wayne York, I also received the support of the late Stephen Ambrose, author of *Undaunted Courage: Meriwether Lewis, Thomas Jefferson, and the Opening of the American West*. Stephen's illness soon made his contributions to the project impossible, and his gracious daughter, author Stephenie Ambrose-Tubbs, continued in his stead. Stephen's endorsement of this effort will always remain a true honor.

In 1999 Maggie Mudd—then director of the University of Montana's Malloy Art Gallery, now the Montana Museum of Art and Culture—contacted me about an exhibition, and I told her about my Lewis and Clark project. Mrs. Mudd proposed that the University of Montana oversee and manage a nationwide tour. The University of Montana's President George Dennison, then Vice President Robert Frazier, and Barbara Koostra, the new director of the Montana Museum of Art and Culture, provided unwavering support during the tour. The exhibition traveled for three years during the entire Lewis and Clark Bicentennial celebration, being exhibited at seven museums across the country.

During the early stages of the project, my wife, Joan, and I planned to sell the paintings before the exhibition began its tour, with the owners agreeing to loan the paintings for the duration of the tour. As the finished paintings grew in number, we came to realize that each work's meaning and value was enhanced exponentially when in the context of the other paintings. And with each passing decade, development would continue to forever alter the historic sites and landscapes described in the Journals. Posterity demanded we at least make an effort to keep the collection together.

During the first couple of years of work, collectors inquired about the possibility of purchasing some of the pieces. Among them was Tim Peterson from Boston, Massachusetts, whose personal art collection focuses on Lewis and Clark and the

fur trade era. He is an enthusiastic and knowledgeable student of both art and the Expedition. He had an immediate understanding and appreciation for what the paintings represented and how they had been executed on-site. He strongly believed all the paintings should be kept together to provide future generations with visual access to the experiences of Lewis and Clark and the Corps of Discovery.

In 2003 I completed the seventy-two paintings, and they began their nationwide tour in celebration of the Lewis and Clark Expedition Bicentennial. The public's enthusiastic response to the exhibition was extremely gratifying to all who played a part in making the tour possible, and attendance records were set at many of the museums.

As the tour drew to a close, what seemed like the end was really just the beginning. Tim Peterson's next idea was that the collection be broadened from 72 paintings to 100, in order to show more of the Expedition's historic achievements and remarkable experiences, thus "100 Paintings Illustrating the Journals of Lewis and Clark." The idea was immediately appealing. In the production of the first seventy-two paintings, I had become aware of many aspects of the Expedition that I had not explored. Tim's interest in serving as a patron to support additional paintings would make it possible to create a truly complete collection.

We had many lively conversations exploring the possibilities of how we might best tell this complex and gripping story. We wanted to reintroduce the public to the members of the Corps with new information about who they were and what they accomplished. For example, in the painting titled "Glimpsing Freedom: York's Journey with the Corps of Discovery," we did not want to show York simply as a curiosity to the Indians. We wanted to say more about this remarkable man and his place in history; and with the help of the recent biographical work of the late Robert Betts, I think we did.

Built on our common vision and always valuing each other's talents, perspectives, and observations, our partnership has provided renewed energy in bringing this project to its fruition. Like Lewis and Clark, the collection's final form and importance is a reflection of a partnership. I will always be grateful to Tim for the enthusiasm, support, energy, and vision he has so generously brought to this project. ॐ

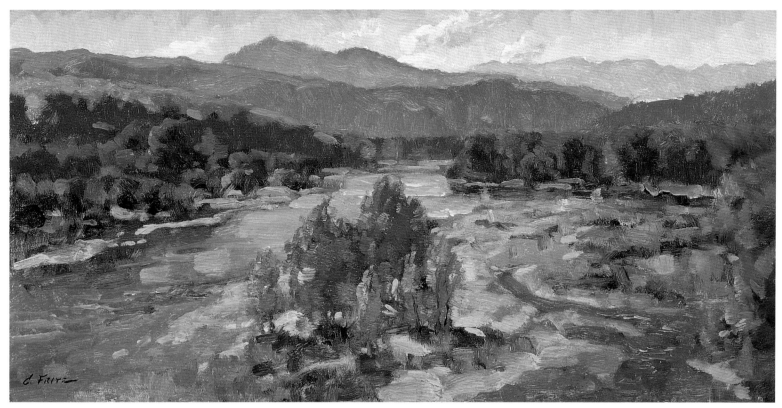

"View over Clark's River"

8" x 16" oil on board

Locations of Scenes Portrayed in the Paintings

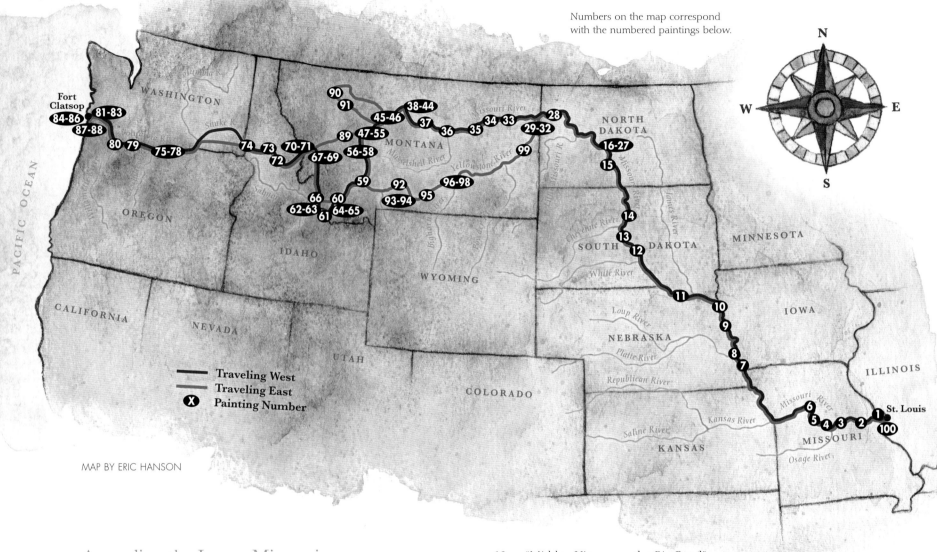

Numbers on the map correspond with the numbered paintings below.

MAP BY ERIC HANSON

Ascending the Lower Missouri

1 "The Sergeant's Shot, Winter at Wood's River"

2 "Captains Lewis and Clark Departing for the Northwest Passage, 1804"

3 "At the Mouth of the Osage River"

4 "Study of the White Pirogue"

5 "Our Keelboat at Rest"

6 "Midday at Prairie of Arrows—June 9, 1804"

Experiencing the Plains

7 "The White Pirogue under Sail"

8 "Addressing the Otos and Missouris at Council Bluffs— August 3, 1804"

9 "View over the Missouri from Black Bird's Grave"

10 "The Burial of Sergeant Floyd"

11 "Hide Tipis of the Yankton Sioux"

12 "Midday View over the Big Bend"

13 "Evening of Ceremony with the Teton Sioux— September 26, 1804"

14 "The Pronghorned Goat"

15 "Abandoned Indian Village, Upper Missouri River"

Winter at Fort Mandan

16 "The Discussion"

17 "The Mandan Buffalo Hunt—December 7, 1804"

18 "Bartering for Corn, Interior of Fort Mandan"

19 "Our Boats, Gripped in Ice"

20 "Study for Mapping the Missouri"

21 "Mapping the Missouri: Winter Afternoon at Fort Mandan"

22 "Captain Clark's Hunting Party Departing"

23 "Nightfall in a Mandan Village"

24 "Winter Sun on the Knife River"

The Origins of the Lewis and Clark Expedition

In 1803, when President Thomas Jefferson pondered the future of the soon-to-be-purchased Louisiana Territory, he predicted that it would take twenty generations, or 400 years, to settle the vast region. He could not have imagined the rapidity with which his nation would conquer, settle, exploit, utilize, and cherish this expansive portion of North America.

To Americans of the time, Jefferson's was a tremendously grand prediction; yet considering what has happened in the last 200 years, his vision was modest, to say the least. Consider the world he knew: The fastest form of land transportation was on the back of a horse, the same as it had been for generations before him. Written communication by post could take weeks; if transmitted by sailing vessels across the ocean, it took months. Household water was still hauled to the kitchen in buckets dipped from hand-dug wells.

From our modern vantage point, with our computerized vehicles, climate-controlled homes, and instantaneous e-mails, it is hard to fully understand the primitive realities of life in the early 1800s. The mechanical revolution, still in its earliest infancy, had not yet produced the many scientific and technological advances that would propel civilization forward. Jefferson would have accepted as basic truth certain inherent limitations to civilization. As he looked out over the Rivanna River from Monticello and contemplated the massive and uncharted Louisiana Territory, his prediction of 400 years may have seemed even a bit optimistic.

President Thomas Jefferson and the Louisiana Territory

Before Thomas Jefferson was in any position to make grand, presidential predictions, he was embroiled in a hotly contested election. Today we frequently hear the phrase "dirty politics" and that our system has lost civility. Advocacy of this position works only if one completely disregards the study of politics and history. The presidential campaign of 1800 would not have passed very many tests of civility. The election was a pivotal one in our young nation's history, with two

men of two very different philosophies ardently believing that the future of the nation was in peril should the other man win.

The two men at the heart of this debate were President John Adams and Thomas Jefferson. Both men were signers of the Declaration of Independence. In the few years before and after the signing of the Declaration, the two men were united in their vision for the nation's independence, yet during the following two decades their individual perspectives would pit them against each other as political rivals. They ran against each other in 1796, with Adams prevailing by just three electoral votes. Because of election law in effect at the time, Jefferson, by coming in second, became the sitting vice president.

John Adams was a Federalist. The Federalist Party felt that an elite, learned class of men should be in charge of the United States and that power should be centralized in their hands. According to the Federalists, the average man was simply not literate nor qualified enough to make important governing decisions.

Opposing the Federalists were the Democratic-Republicans and their presidential candidate Thomas Jefferson. Jefferson believed that the common man should be instrumental in determining the actions of government and that states' rights should be protected.

The general populace was split equally on these fundamental issues, and the campaign was high-pitched and intense. The Democratic-Republicans charged that electing Adams would lead the fledgling American democracy back in time to the aristocratic and feudal states of Europe. For many colonists, the Revolutionary War was still a vivid memory. It was easy for the Democratic-Republicans to imagine the "powerful few" evolving into the "powerful one" and seeing the sacrifices of the Revolution wasted and the opportunities of the New World lost. The Federalists, on the other hand, accused Jefferson of supporting the French Revolution and maintained that if the Democratic-Republicans were to win the election, chaos would envelop the country and mob rule could not be far behind. With venomous personal attacks, the two sides advanced their opposing views. Outrageous newspaper articles took character assassination to new levels. Sympathetic to Adams, the *New York Post* wrote, "A vote for Jefferson is a vote against God. If he is elected president, the people of the nation will receive the just vengeance of an insulted heaven, will witness our dwellings in flames, hoary hairs bathed in blood, female chastity violated and children writhing on the pike in Halberd."

Like the previous election in 1796, the hotly contested 1800 election resulted

in a tie and had to be settled in the House of Representatives. Following seven days of deadlocked votes, Thomas Jefferson was elected by one vote. This president, who now enjoys his nation's utmost admiration, came into office mistrusted, feared, and despised by half of the electorate.

Today we take for granted that after every election, power will be transferred peacefully from one presidential administration to the next. In 1801, however, the peaceful transfer of power had only happened once before: between George Washington and John Adams in 1797. With the political climate at a boil, it was a landmark moment in our nation's history when Jefferson peacefully assumed the presidency, though the disgruntled Adams was noticeably absent, having been whisked out of Washington in his carriage as Jefferson took the oath of office.

As Jefferson began his first term in January 1801, he had many pressing concerns. Of primary importance to him was the loyalty of his military officers. In the final hours of his presidency, John Adams had loaded the military with Federalist officers. With the deep schism in the nation between the Federalists and the Democratic-Republicans, Jefferson wanted to ensure that there would be no dissent in the military and that the officers would support him and Democratic-Republican ideals.

Meriwether Lewis had been a paymaster and courier between various forts and knew the officers well. This familiarity with the political sympathies of the officers was one of the reasons Jefferson chose to hire Lewis, whose rank had recently been raised to captain, as his personal secretary. Based on Lewis's evaluations, Jefferson proceeded to purge the military of the newly commissioned officers who were deemed unreliable.

With all of the pressing issues Jefferson faced, the Louisiana Territory was not on the top of his list. The Louisiana Territory, first claimed for France in the name of Louis XIV in 1682, was a vast wilderness largely unseen by any but the native peoples. Lying a thousand miles or two months' travel west from Washington, D.C., it included all of the drainages of the Missouri River. Excluding Texas, it encompassed all of the land from Canada in the north to the Gulf of Mexico in the south, and from the Missouri–Mississippi river junction west to the Rocky Mountains.

The perceived riches, resources, and commercial potential of the Louisiana Territory made it the envy of nations bent on foreign colonization in the New World. Aspiring to achieve control of the territory were Britain, France, Spain,

Russia, and the United States. To the north in Canada, Britain and France, both based on the Atlantic coast, vied for dominance. British explorers, Hudson's Bay Company traders, and French "voyageurs" had used the vast waterways to penetrate the continent and had already probed the northern boundaries of the Louisiana Territory. Since the late 1500s they had been exploring and expanding their influence in the region and by 1800 were already managing successful fur trading networks. To the southwest, Spain's 200-year presence in the New World had been extensive, but by 1801 its holdings were in a state of decline; Spain even held title to the Louisiana Territory, albeit tentatively. To the northwest in today's Alaska, Russia enjoyed an uncontested position in the fur trade, and its ships had sailed south. In closest proximity to the territory was the young, rebellious, loosely confederated group of sixteen colonies calling itself the United States of America. Often overlooked were the Native American tribes already inhabiting the Louisiana Territory and the West; in 1800 most were unaware that distant civilizations were bartering over their very existence.

Spain had retained ownership of the Louisiana Territory since 1762, but by 1800 the nation's dwindling ability to defend the distant territory precipitated the retrocession of the land back to France, the previous owner. Napoleon Bonaparte, First Consul of France, had drained his nation's treasury with his perpetual appetite for war. Preoccupied with his adventures in Europe, he took stock of his situation: His resources were spread thin and considering the irrepressible vitality of the American settlers always pressing west, defending the remote Louisiana Territory could become increasingly difficult, perhaps impossible. Napoleon concluded that selling the territory would guarantee a gain, while waiting could result in a total loss. Suddenly and unexpectedly, President Jefferson was offered the opportunity to purchase the Louisiana Territory, an acquisition that would double the size of the United States. Immediately Jefferson and the U.S. Congress began secret negotiations with Napoleon to acquire the land. Jefferson's critics were quick to point out that he was reversing his campaign promises regarding both prudent government expenditures and the general acceptance of the existing boundaries of the sixteen United States. Despite these criticisms, which in point of fact were true, Jefferson forged ahead, energized by this monumental opportunity.

Negotiations succeeded, and on July 4, 1803, France sold the 512-million-acre Louisiana Territory to the United States for what worked out to be 3 cents per acre. Despite what today seems like a bargain, many at the time considered the

deal ludicrous folly and felt the United States was already land rich and cash poor. The powerful aristocratic nations of the world looked on with smug skepticism. In their minds the odds favored collapse of this struggling young democracy, certainly not expansion. Soon enough, they reasoned, this vast parcel of valuable real estate would find its way back onto the world market.

With Louisiana Purchase negotiations headed toward fruition, President Jefferson moved quickly to implement a plan he had been fostering for years. (Lewis would receive news that the purchase was complete while he was on the Ohio River in the fall of 1803, heading west to join Clark and begin their trek.) Jefferson's dream was to send an expedition into the Louisiana Territory, to survey economic resources from furs to minerals, map the rivers, inform native nations about the new government, and confirm or lay to rest the fading theory of a Northwest Passage, an inland water route to the Pacific Ocean. With Jefferson's stipulation that the cost of the expedition be kept low enough to win Congress's approval, Captain Lewis was put to work preparing a budget. With no concrete information on which to base his budget, Lewis was forced to use almost arbitrary numbers, which, when he totaled them, amounted to $2,500. This number achieved Jefferson's requirements, and Congress approved the expenditure and the expedition (which, in the end, cost $38,722).

Despite his many critics and the difficult political issues he confronted, time has been a benevolent judge of Thomas Jefferson. His controversial decision to purchase the Louisiana Territory has proven to be a crowning achievement and a pivotal moment in the creation of the United States as we know it today.

The Lewis and Clark Expedition

For two years, Captain Meriwether Lewis dedicated himself to creating what President Jefferson called the Corps of Discovery. In Philadelphia, Harpers Ferry, Pittsburgh, Louisville, and St. Louis, he gathered men and equipment and acquired the skills he and President Jefferson anticipated he would need to thoroughly explore and document the land from the Mississippi River to the Pacific Ocean.

Early in their planning, Jefferson and Lewis recognized the obvious need for a second officer to share in Lewis's many responsibilities. This second officer would also serve as a predetermined successor should Lewis become incapacitated. William Clark, known both to Jefferson and Lewis, quickly became Lewis's first choice to

accompany him on the potentially dangerous journey. The men had met in 1795, when then Ensign Lewis served under then Lieutenant Clark in a select company of riflemen at Fort Greenville, in the Ohio Territory. Clark left the military shortly thereafter, but the men had developed a strong friendship and stayed in contact during the ensuing years. With the approval of President Jefferson, Captain Lewis wrote a letter of invitation to William Clark to accompany the Corps of Discovery to the Pacific and back again. Included in the offer was the promise that Clark would be reinstated at the rank of captain and serve equally with Lewis.

On May 14, 1804, the three boats of the Lewis and Clark Expedition slipped into the current of the Mississippi River at Camp Wood River (Camp River Dubois) on the Illinois side, just opposite the wide, gaping mouth of the Missouri River. The two pirogues—one red and one white, each approximately forty feet long—and the larger fifty-five-foot-long keelboat then crossed the Mississippi and entered the Missouri River. Bystanders watched as the boats became smaller and smaller; the shouts of the men and the splash of their oars faded away until the Corps of Discovery rounded a bend in the river and disappeared behind a distant, faint screen of trees.

Poling, sailing, rowing, and cordelling (towing by ropes) were the only means of moving the boats upstream against the Missouri's powerful current; ten miles a day was considered a good pace. Although dangerous and untamed, the river was not completely uncharted. The 1,600 miles up to the Knife River villages of the Mandan Indians, in today's North Dakota, had been plied for more than a century by adventurous British, Spanish, and French traders. Lewis, thus, had access to maps of this lower stretch of the river. Crude maps, however, did not make the wilderness a safe place, and trials and mishaps plagued the Corps, including storms, waterfalls, caving riverbanks, and swollen currents that resulted in careening boats and broken masts, as well as a few tense and explosive negotiations with native tribes. Desertions, court-martials, and lost party members threatened the success of the Expedition from within.

When the Corps reached the Knife River villages in the autumn of 1804, they built a crude shelter they christened Fort Mandan in honor of the Mandan Indians, whose company the men would enjoy and rely on throughout the long bitter winter to come. It was here that two new members were added to the Corps. A young, pregnant Shoshone girl named Sacagawea and her husband, Toussaint Charbonneau, were hired as translators.

Leaving the Mandans in the spring of 1805, the Corps crossed today's Montana, encountering grizzly bears, rattlesnakes, hailstorms, blazing heat, and unforeseen portages. By September they were at the foot of the Rocky Mountains, where they bartered for horses with the Shoshone Indians. As they crossed the Rocky Mountains just southwest of today's Missoula, Montana, they were caught in an early snowstorm and found themselves in brutal winter conditions. Lewis recorded in his journal, *"the road was excessively dangerous along this creek being a narrow rockey path generally on the side of steep precipice, from which in many places if ether man or horse were precipitated they would inevitably be dashed in pieces."* Lack of game forced the men to eat two colts that were accompanying their pack horses. Weakened from hunger and the cold, the men emerged from the mountains eleven days after entering them. They recuperated in the villages of the Nez Perce Indians, who lived along today's Clearwater River in central Idaho. Regaining their strength, the men crafted canoes from the large ponderosa pines and returned to river travel, descending the Clearwater River to the Columbia River. More than 2,000 miles separate St. Louis, which is near sea level, and the Continental Divide in the Rocky Mountains; it's only 1,000 miles from the Continental Divide to the Pacific Ocean. Consequently, the rivers that flow to the Pacific lose the same amount of elevation in half the distance, and the Corps faced fierce rapids that seemed to have no end.

As their second winter approached, the Corps finally reached the Pacific Ocean, where Captain Clark wrote, *"Great joy in camp we are in View of the Ocian, this great Pacific Octean which we been So long anxious to See."* Their goal finally reached, they would spend still more torturous days pinned down by storms on the exposed beaches of today's Washington state. Taking the Clatsop Indians' recommendation, they found refuge on the south side of the Columbia River in today's Oregon. They built a new stockade, Fort Clatsop, named after the tribe that provided them with salmon and berries, as well as valuable information.

Constant rain made the winter at Fort Clatsop a miserable one, and by March 1806 the men were anxious to vacate the flea-ridden fort and begin their journey back to St. Louis. They retraced their route up the Columbia and Clearwater rivers to the Nez Perce villages; from the Nez Perce and others they bartered for horses to once again cross the Rocky Mountains.

Once on the east side of the Rockies, the Captains elected to implement a plan they had been considering throughout the winter at Fort Clatsop. They would split up so that they could explore more country. Captain Clark would go south and

east until he intersected the Yellowstone River near today's Livingston, Montana, which he would then follow to the east until he came to its confluence with the Missouri. Captain Lewis would take a small contingent of men and explore the northern reaches of the Marias River. Another group of men under Sergeant Ordway would retrieve the cached canoes from their 1805 "Camp Fortunate" near today's Dillon, Montana, and descend the Jefferson River and then the Missouri as well. The three parties planned to rendezvous at the confluence of the Yellowstone and the Missouri. It was a bold plan to split the men into such small groups, but it is indicative of how confident the Captains had become at traversing this frontier.

Perhaps confidence drifted into complacency for both Captains. During the following weeks, Captain Clark lost all fifty horses to capture by, probably, the Apsáalooke (Crow, Absaroka) Indians along the Yellowstone, and Captain Lewis fell into a violent but avoidable incident with the Blackfeet while exploring the Marias; it proved to be the most critical error of the entire Expedition. While returning from the Marias River, Lewis and his three men encountered a group of young Blackfeet warriors. They smoked with them into the evening under a makeshift shelter along today's Two Medicine Creek. Lewis apparently did not recognize his vulnerability and camped with the Blackfeet overnight. Although he assigned men to overnight guard duty, at first light he and his men were caught by surprise when the Blackfeet attempted to take the men's firearms and horses; losing them would be a death sentence for Lewis and his men on those vast plains. In the ensuing confusion, one Blackfeet man was stabbed to death and Lewis shot another. For more than two years, the Corps had been interacting with the many Indian tribes and there had been little violence and no mortal incidents until this moment. After the brief skirmish ended, Lewis and his men were in great fear that the Blackfeet who had escaped would bring back warriors seeking retaliation. The men picked the best of the remaining horses and rode hard for the Missouri River throughout the day and into the night, only stopping briefly for a rest at 2:00 A.M. Soon resuming their march, they arrived at the Missouri after riding about 100 cross-country miles, where they happened to meet up with Sergeant Ordway's group in the canoes. With the two small groups together again, they hastily descended the Missouri to get out of Blackfeet country. They eventually made their appointed meeting with Captain Clark on August 12, 1806, below the confluence with the Yellowstone River.

Eager to return to their family and friends, the reunited Corps rapidly

descended the Missouri in just six weeks. *"The party being extreemly anxious to get down ply their ores very well,"* Captain Clark recorded on September 20, 1806. They arrived in St. Louis on September 23 to a hero's welcome.

The Corps of Discovery had been gone for twenty-eight months. The sight of them paddling into St. Louis caused great delight and *"every person, both French and americans Seem to express great pleasure at our return, and acknowledged them selves much astonished in Seeing us return. they informed us that we were Supposed to have been lost long Since…."*

Upon their return to Washington, D.C., Lewis reported that they had found no Northwest Passage, and decades of subsequent exploration would only confirm there was not one to be found. The two Captains had led the Corps of Discovery more than 8,000 river and overland miles to the Pacific Ocean and back again, collecting specimens, documenting the geography, guiding their men through many perils, and meeting with more than fifty different native tribes. The Lewis and Clark Expedition would be remembered as the most successful expedition in American history. The Captains and the members of the Corps of Discovery could take immense comfort in the knowledge that they had executed their mission to near perfection. ❧

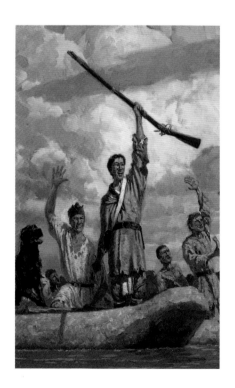

The Creation of the Paintings

"The work we are now doing is,
I trust, done for posterity,
in such a way that they need not repeat it.
We shall delineate with correctness
the great arteries of this great country:
those who come after us will…
fill up the canvas we begin."

<div align="right">

—PRESIDENT THOMAS JEFFERSON,
in a May 25, 1805, letter to
William Dunbar regarding the
Lewis and Clark Expedition

</div>

When in the course of my research I came across these words in an 1805 letter President Jefferson wrote to surveyor William Dunbar regarding the Lewis and Clark Expedition, the message struck me as deeply prophetic. As I set forth to illustrate the Lewis and Clark Journals, I quickly adopted his words as my mission.

To *"delineate with correctness"* was my personal mantra and goal as I began to create the collection of paintings, and I pored over many of the volumes that detail the lives and achievements of these epic explorers. In the 200 years since the Expedition, many artists have depicted key moments in the Journals, in some cases creating works that have become iconic scenes we carry in our minds. Modern scholarship on the Expedition has greatly increased our knowledge about almost every aspect of the journey and corrected some of the historical inaccuracies, which have been perpetuated over the years.

In order to ensure accuracy in the paintings, I traveled the entire route of the Expedition twice, locating and visiting the sites of noteworthy events in the Journals and painting field studies there. I sometimes used a canoe to reach

CHARLES FRITZ PAINTING ON LOLO PASS, ALONG THE IDAHO/MONTANA BORDER.

isolated locations. At other times I had to seek out landowners in order to get permission to access certain locations or exceptional vantage points. If the Journals indicated time of day, I would take that into account as I planned a painting. In order to capture the unique characteristics of season, I traveled to the sites in the same season as the Corps of Discovery—making a point to exclude species of trees or vegetation introduced after the years Lewis and Clark visited.

My work, which began in 1998, coincided with the widespread use of the Internet. From my studio, I was able to access information about the Expedition, peruse museum collections, and locate curators and scholars. With this wonderful resource at my fingertips, I was able to incorporate the artwork of the past and modern discoveries and scholarship, creating a fresh, updated visual of the Journals. I gratefully acknowledge my debt of gratitude to the many collectors, historians, and scholars who generously helped me achieve a level of accuracy in these paintings that reflects our current knowledge and understanding.

Historical accuracy is paramount, but there is another obvious component: the art itself. During my thirty years as a professional artist, my aesthetics have always leaned toward "representational" art—that which represents reality through expressive, spontaneous mastery of the medium. The application of paint in representational painting allows the viewer to be endlessly intrigued by not just the image and subject of the painting but also the physical qualities of the medium.

In *100 Paintings Illustrating the Journals of Lewis and Clark,* I sought to communicate the storyline accurately. I also wanted the paintings to be well designed, luminous, and painted with the brushwork and enthusiasm of an artist who is working from life—outside, in the presence of the actual scene. Working within the framework of time-honored principles, my goal was to please the historian, the student of art, and of course the general public.

In the late 1800s the French Impressionists revolutionized painting when they began to explore the phenomenon of light reflecting off the surfaces of objects. They attempted to capture in paint the luminosity we all experience when we look at a sun-drenched landscape and the objects within it. They were immediately influential, and, by the turn of the eighteenth century, artists around the world were painting *en plein air,* in outdoor daylight. I believe that the French Impressionist's exploration into luminosity was critical to the art that would eventually document the western United States. Western artists such as Remington,

Dixon, Berninghaus, Dunton, and Hennings and scores of illustrators were influenced by the Impressionists as they sought to capture the grandeur of the West, with its vast illuminated skies and broad, varied landscapes. My work flows out of this 150-year-old tradition. I believe that all of us who paint Western landscapes owe a "tip of the brim" to the French Impressionists.

Sometimes painting on location is idyllic, but more often it is a strenuous and rigorous experience. The artist has to contend with conditions such as wind, heat, cold, changing light, and even bugs. So why do we subject ourselves to these discomforts? For me, it's about going the extra mile to produce a painting that best communicates the unique qualities of the scene on that day. For example, take the painting on page 90, "Sunrise over Beaver's Head Rock—August 8, 1805." I camped at the site in Montana for several days and painted the landmark four times. This gave me an appreciation for and an intimate understanding of the formation and how it looks in different conditions. This does not happen for the artist who relies on a quick drive-by, takes a few quick snapshots, and uses the resulting photos for reference. Back in the studio, it may be months before there is an opportunity to paint the larger painting from this reference trip. Where will the passion come from to produce an emotional, powerful painting if from the beginning the artist has had no relationship with the site? Painting on location takes time; the reward for being on-site is a heightened appreciation of and sensitivity to the nuances of the place. With that heightened understanding, the artist brings a higher level of insight and energy to the work—and viewers respond.

In art, a principle called dynamic symmetry provides an underlying mathematical framework that can help artists achieve variety, unity, and movement in their work. For example, a round ball is an example of static symmetry; both sides mirror each other. A chicken egg is an example of dynamic symmetry; it is not completely symmetrical. Dynamic symmetry is a numerical ratio, 1 to 1.618, that can be found in all aspects of nature, from the progressive geometric spirals of the seeds on the head of a sunflower to the structure of the cochlea in the inner ears of humans. It is an underlying and pervasive law of nature, and consequently it is innately pleasing to the human aesthetic. Dynamic symmetry communicates progression and movement, exemplified for instance by the progression of a ram's horn; your eye will naturally follow the curve all the way out to the horn's tip. This principle helps the artist to both divide a rectangular canvas in a way inherently

CHARLES FRITZ PAINTING CAPTAIN CLARK'S DUGOUT IN "OUR CANOES ON THE RIVER ROCHEJHONE" IN MONTANA.

pleasing to the human eye and to place objects in the painting in such a way as to create stronger compositions. While working in the field these principles are generally applied intuitively, but in the studio while working on large, complex paintings where there are many elements, I spend hours planning and designing the composition before beginning to paint.

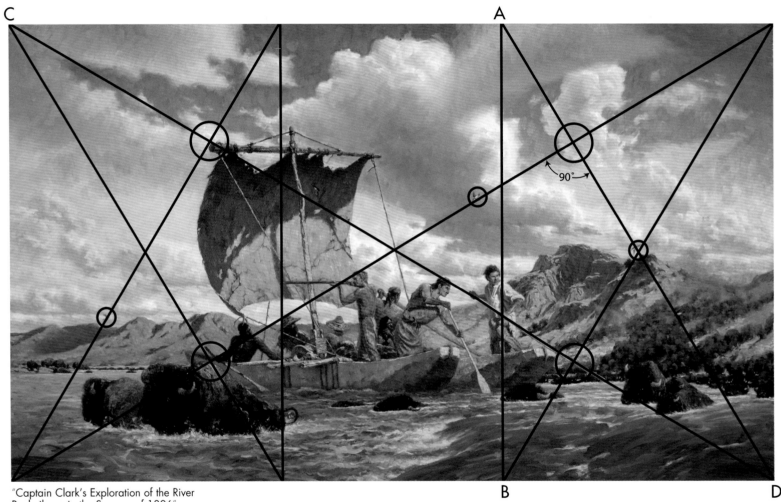

"Captain Clark's Exploration of the River Rochejhone in the Summer of 1806"

36" x 60" oil on canvas

An application of dynamic symmetry can be seen in the painting "Captain Clark's Exploration of the River Rochejhone in the Summer of 1806." Initially I studied the Journals to identify an event that I wanted to portray, then I traveled to a site near Terry, Montana, where Captain Clark recorded many encounters with herds of migrating bison. I created some field studies focusing on the river and the dramatic bluffs along its banks. As shown above, I used

the most important, primary lines of dynamic symmetry to decide where to place the elements on the canvas. It is possible to continue subdividing the canvas with more lines to determine where to place the painting's secondary subjects. The center of interest and the most important subject in this painting is Captain Clark, whose center of gravity falls on the vertical line AB. Another critical line is CD, which passes through the gaze of the man with the paddle and continues down through the pole in Captain Clark's hands, where it eventually intersects a bison, the point where the suspense in this painting is located. Additional minor subjects in the painting utilize the principles of dynamic symmetry, from the placement of the flying bank swallows to the shadow of the mast on the sail. The four large circles indicate the "eyes" of the rectangle; their locations are important points in the composition. At the location of each "eye," there is something of note. It is this careful placement of elements that creates a sense of unity and movement in this work.

In 2008, after ten years of working on these paintings, it was time to complete "Glimpsing Freedom: York's Journey with the Corps of Discovery," the last painting in the collection. I felt strongly about the message that Tim and I wanted to communicate about York. This member of the Corps who had been a slave since his birth experienced a level of personal freedom and social value that never would have been possible in the colonies. I had held this painting in reserve as my last, knowing its message would provide me with the motivation I would need to finish the one-hundredth painting with the same energy and enthusiasm that I had had for the first painting. This painting is representative of all of the paintings. The collection is about art and it is about history. It was said during the Lewis and Clark Bicentennial tour of the exhibition that this collection is like a string of pearls—each has value, but strung together, one beside the other, the pearls create a wonderful necklace. That has been the art part of this journey. History, the other part, teaches us, makes us wise. We all stand on the shoulders of those who have gone before us, and this fact has motivated me to honor not only the members of the Corps of Discovery but the indigenous peoples they met as well.

We are the beneficiaries of the hardships and sufferings of our ancestors, and when I stop to contemplate their stories, their portraits, their photographs, their failings and their accomplishments, it is impossible for me to not identify with their human experience. I hope that in some measure, I have fulfilled President Jefferson's wish that "those who come after us will…fill up the canvas we begin."

CHARLES FRITZ PAINTING "CROOKED FALLS" NEAR GREAT FALLS, MONTANA.

The Paintings

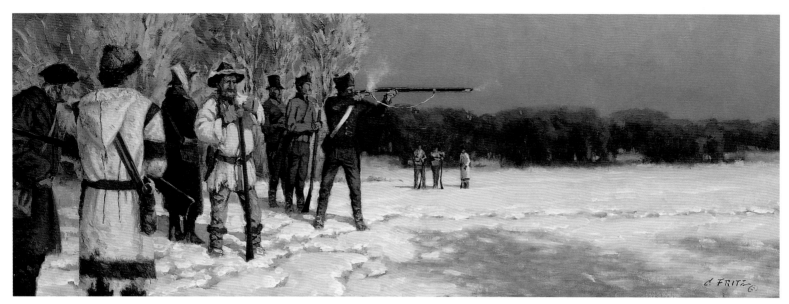

"The Sergeant's Shot, Winter at Wood's River"
10" x 28" oil on canvas

"Several men Come from the Countrey to See us & Shoot with the men, they bring Sugare &c. to trade ...I put up a Dollar to be Shot for, the two best Shots to win Gibson best the Countrey people won the dollar—..." — CAPTAIN WILLIAM CLARK, JANUARY 1, 1804

"...the Party made up a Shooting match, with the Country people for a pr. [pair of] Leagens, Reuben [sic] Fields made the best Shot..." — CAPTAIN WILLIAM CLARK, JANUARY 16, 1804

According to initial plans, the Corps of Discovery was to have been 600 miles up the Missouri at the onset of winter in 1803. Now severely behind schedule, on December 12 Captain Clark took the keelboat north from St. Louis to the mouth of the Wood River, in today's Illinois. Resigned to the winter's delay, they built their quarters, which they called "Camp River Dubois." Looking across the Mississippi, they could see the mouth of the Missouri River at its commanding entry into the Mississippi.

The winter months were spent building huts, shooting, marching, drinking, and fighting. The Captains needed to keep order and create discipline. At times their only alternative was to overlook inconsistent behavior in otherwise good candidates. The Captains were always evaluating which of the men would earn a permanent place on the Expedition. Later, far into the continent, their judgment would be rewarded as these young men, forged in toil and discomfort, would prove themselves many times.

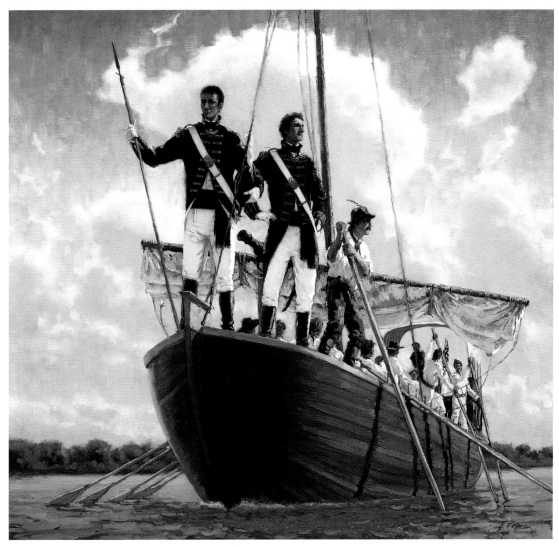

"Captains Lewis and Clark Departing for the Northwest Passage, 1804"

32" x 34" oil on canvas

"The object of your mission is to explore the Missouri river, & such principal stream of it, as, by it's course and communication with the waters of the Pacific ocean, whether the Columbia, Oregon, Colorado or any other river may off the most direct & practicable water communication across this continent for the purposes of commerce."
— PRESIDENT THOMAS JEFFERSON'S INSTRUCTIONS
TO CAPTAIN MERIWETHER LEWIS, JUNE 20, 1803

In addition to finding and mapping the most direct and practicable route to the Pacific, Lewis and Clark were assigned a diplomatic mission as well: *"…allay all jealousies as to the object of your journey, satisfy them [the Indians] of it's innocence, make them acquainted with the position, extent, character, peaceable & commercial dispositions of the U. S. of our wish to be neighborly, friendly & useful to them…"* (President Thomas Jefferson, June 20, 1803). This, along with the plant, animal, and mineral surveys they were to take, would require the combined total concentration of the men and their Captains for the next three years.

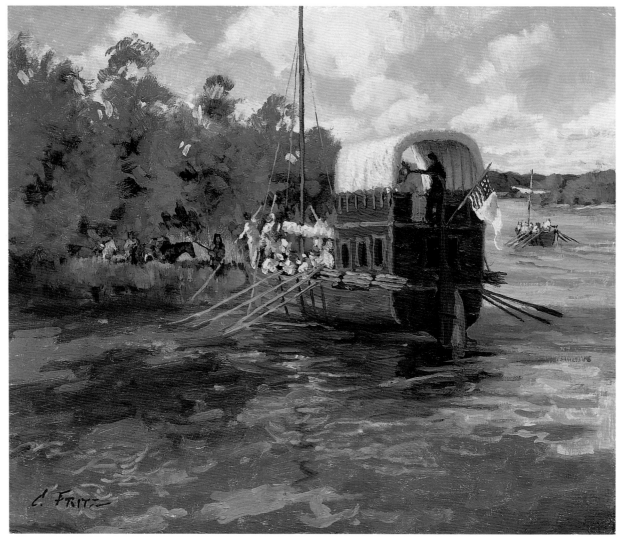

"At the Mouth of the Osage River"
10" x 12" oil on board

"the wind a head from the West the Current exceedingly rapid Came to on the point of the Osarges River on the Labd Side of the Missouries this osages river Verry high, [we] felled all the Trees in the point to Make observations Sit up until 12 oClock taken oservation this night"

— CAPTAIN WILLIAM CLARK, JUNE 1, 1804

The Corps camped on the point of land between the confluence of the Missouri and Osage rivers in today's central Missouri. A prominent bluff stands one hundred yards off the Osage River. On the bluff's point, near some Indian burial mounds, the trees were cleared away enough so that Clark could make his observations of latitude and longitude.

The Corps had started out with two horses for the hunters. As the boats moved up the Missouri, Drouillard, the Expedition's most dependable hunter, regularly came to the riverbank to rendezvous with the boats. He and any companions would deliver the large quantities of fresh meat needed to feed about forty-five hard-working men.

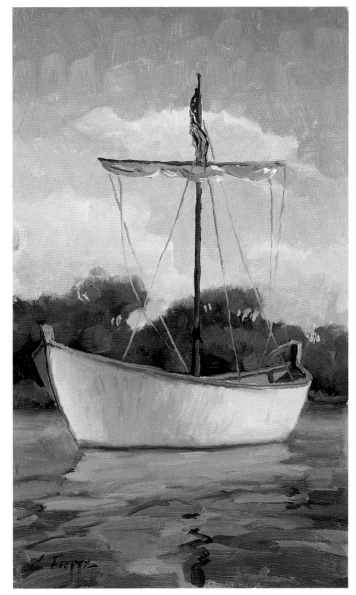

"Study of the White Pirogue"
10" x 6" oil on board

This study, done on calm water in the lower stretches of the Missouri, belies the calamities that would later follow the white pirogue. On May 31, 1805, Captain Lewis wrote, *"The toe rope of the white perogue, the only one indeed of hemp, and that on which we most depended, gave way today at a bad point, the perogue swung and but slightly touched a rock, yet was very near overseting; I fear her evil gennii will play so many pranks with her that she will go to the bottomm some of those days."*

Despite the white pirogue's numerous moments of peril, it went all the way to the Great Falls of the Missouri where the Corps cached it, using the mast in the construction of the wooden carts that portaged the canoes. On the return trip in 1806, Sergeant Ordway's party picked up the pirogue and returned to St. Louis. The red pirogue, cached earlier at the mouth of the Marias River, rotted and was unfit for use during the return trip.

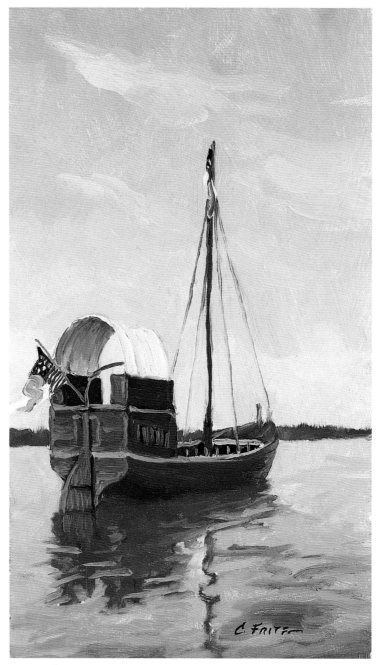

"Our Keelboat at Rest"
10" x 6" oil on board

Fifty-five feet in length with an eight-foot beam and capable of carrying up to fourteen tons, the keelboat served the Expedition well on the first leg of the trip. After the winter at Fort Mandan, the keelboat and its crew returned to St. Louis with the specimens and articles the Captains had collected.

"Midday at Prairie of Arrows—June 9, 1804"
10" x 15" oil on board

"We passed the Prairie of Arrows, and Arrow creek on the south side. This is a beautiful country, and the land excellent."
— SERGEANT PATRICK GASS, JUNE 9, 1804

This view, painted from Arrow Rock bluff, depicts the Missouri as it probably looked on June 9, 1804. The river is laden with silt and swollen from recent rains. It was in this vicinity that the boatmen were tested by fast-running channels and submerged logs. After a "disagreeable and Dangerous Situation" when the keelboat was in imminent peril, Captain Clark wrote, *"I can Say with Confidence that our party is not inferior to any that was ever on the waters of the Missoppie* [Mississippi]."

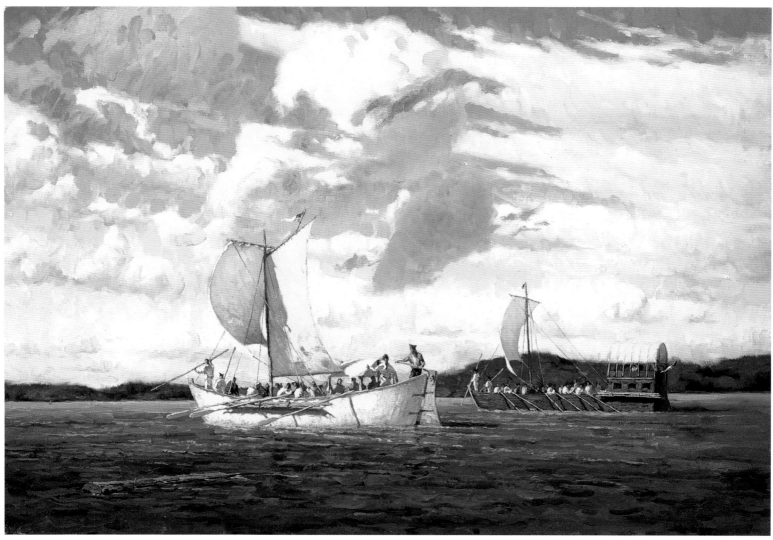

"The White Pirogue under Sail"
20" x 30" oil on canvas

"Swam over the two remaining horses to the L.S. with the view of the Hunters going on that Side, after Getting everry thing Complete, we Set Sale under a gentle breeze from the South and proceeded on…"
— CAPTAIN WILLIAM CLARK, JULY 27, 1804

For the previous five days, the Corps had encamped on the Iowa side of the Missouri River opposite of today's Omaha, Nebraska. They called it Camp White Catfish, after one caught by Private Goodrich. The Corps repaired oars and poles, worked hides, and made an unsuccessful attempt to find the Oto people.

Refreshed and rested, they left Camp White Catfish on July 27 under good weather conditions and were able to use their sails due to a southern breeze. With nature lending a hand, they sailed fifteen miles that day. The following few days proved to be successful ones, with the Expedition encountering the Oto and Missouri tribes at the now-famous Council Bluffs.

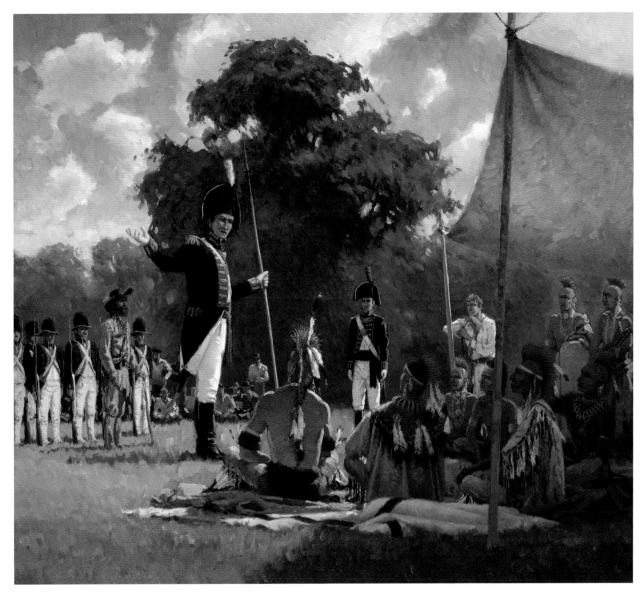

"Addressing the Otos and Missouris at Council Bluffs—August 3, 1804"

32" x 36" oil on canvas

"mad[e] up a Small preasent for those people in perpotion to their Consiqunce. also a package with a meadile to accompany a Speech for the Grand Chief (which we intend to send to him) after Brackfast we Collected those Indians under an orning of our Main Sail, in presence of our Party paraded & Delivered a long Speech to them expressive of our journey and the wirkes of our Government..."

— CAPTAIN WILLIAM CLARK, AUGUST 3, 1804

The Oto and Missouri tribes had traded with both the Spanish and French prior to Lewis and Clark's arrival in 1804. The trading, however, had been inconsistent, and the tribes viewed the two European countries as being a bit stingy and undependable. On the event of the Expedition's first council, the Captains were fortunate to have an audience who shared their desire for consistent and peaceful trading relationships.

"View over the Missouri from Black Bird's Grave"
10" x 12" oil on board

"…we landed at the foot of the hill on which Black Bird The late King of the mahar who Died 4 years ago & 400 of his nation with the Small pox was buried…and went up and fixed a white flag bound with Blue white & read on the Grave which was about 12 foot Base & circueller, on the top of a Penical about 300 foot above the water of the river, from the top of this hill may be Seen the bends or meanderings of the river for 60 or 70 miles round & all the County [sic] around the base of this high land is a Soft Sand Stone…"
— CAPTAIN WILLIAM CLARK, AUGUST 11, 1804

Black Bird was a noted chief of the Omahas. He was an energetic and strong leader, and the Omahas rose to prominence under him on the eastern plains. He also encouraged trade with the merchants doing business on the Missouri in the years prior to 1800. It was this close association with the traders in the late 1700s that brought the smallpox into his tribe; sadly the disease had decimated their numbers by the time the Corps of Discovery went up the river in August of 1804.

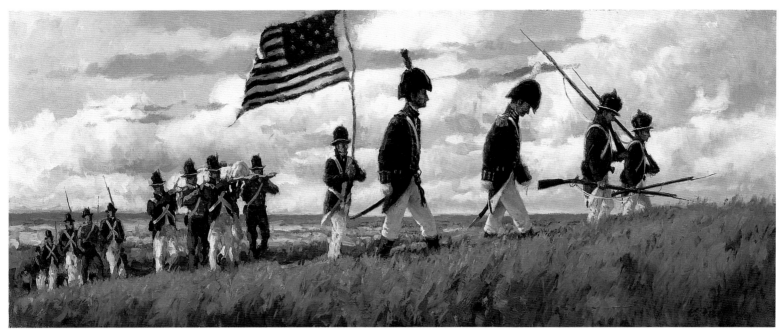

"The Burial of Sergeant Floyd"
12" x 30" oil on canvas

"...we Set out under a gentle breeze from the S. E. and proceeded on verry well— Serjeant Floyd as bad as he can be no pulse & nothing will Stay a moment on his Stomach or bowels—

 Passed two Islands on the S. S. and at the first Bluff on the S S. Serj' Floyd Died with a great deel of Composure, before his death he Said to me, "I am going away" ["]I want you to write me a letter"— We buried him on the top of the bluff ½ Miles below a Small river to which we Gave his name, he was buried with the Honors of War much lamented; a Seeder post with the...Name Sergt. C. Floyd died here 20th of August 1804 was fixed at the head of his grave— This Man at all times gave us proofs of his firmness and Deturmined resolution to doe Service to his Countrey and honor to himself after paying all the honor to our Dececed brother we Camped in the mouth of floyds River about 30 yards wide, a butifull evening.—"
 — CAPTAIN WILLIAM CLARK, AUGUST 20, 1804

Sergeant Charles Floyd was the only man to die on the Expedition. Today we know that a ruptured appendix most likely caused his death. In 1804, regardless of where you were in the world, this condition would have been inoperable and fatal.

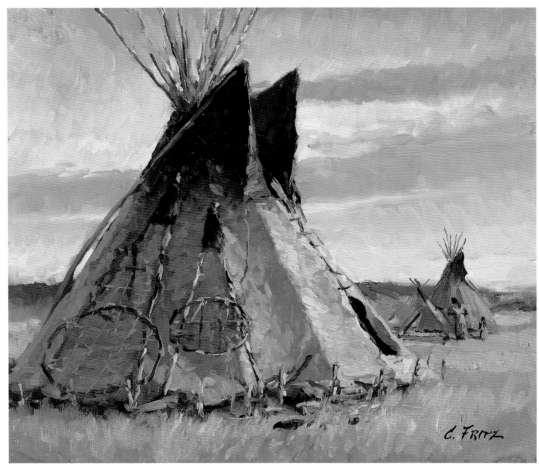

"Hide Tipis of the Yankton Sioux"
10" x 12" oil on board

"...the Camp which was handsum made of Buffalow Skins Painted different Colour, all compact & hand-Somly arranged, their Camps formed of a Conic form Containing about 12 or 15 persons each and 40 in number."
— SERGEANT NATHANIEL PRYOR, AUGUST 29, 1804

"their lodge [village] is verry handsome in a circle and about 100 cabbins in nomber and all whit, made of Buffalow hides dressed white one large one in the center, the lodge for the war dances."
— SERGEANT JOHN ORDWAY, SEPTEMBER 26, 1804

The Plains Indian tipi was the perfect blend of utility and art. It was warm in winter and cool in summer, could be transported easily to follow the bison herds, and was constructed of materials easily procured on the prairie.

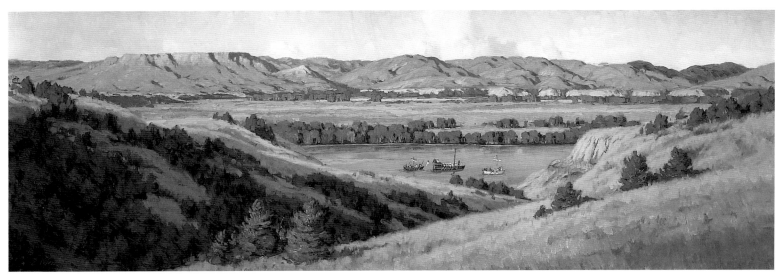

"Midday View over the Big Bend"
18" x 54" oil on board

"…at Daylight proceeded on to the Gouge of this Great bend and Brackfast, we Sent a man to measure step off the Distance across the gouge, he made it 2000 yds. The distance arround is 30 mes."
— CAPTAIN WILLIAM CLARK, SEPTEMBER 21, 1804

The meandering Missouri River provided a constant source of amazement and frustration for the Corps of Discovery. Moving two tons of baggage upriver required plenty of man-power—and a saint-like patience with a river that uncooperatively placed snags, sawyers, and bank cave-ins directly in their way. Located in today's central South Dakota, the "Big Bend," or the "Grand Detour," is a large U-shaped bend in the Missouri River. The bend is thirty river miles long, but its ends are just 2,000 yards apart, making this a very long detour. The stretch would frustrate river men, steamboat captains, and all those involved in Missouri River commerce for decades.

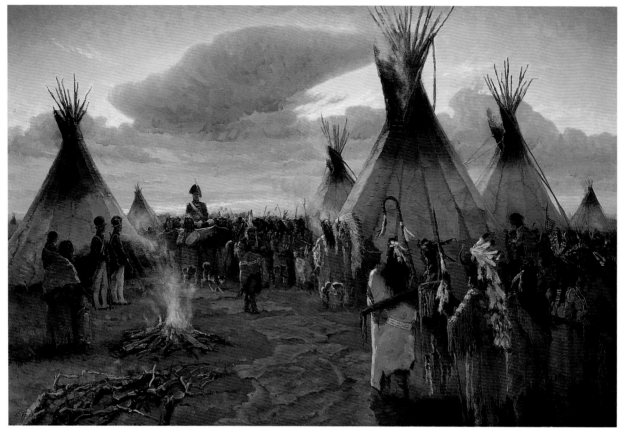

"Evening of Ceremony with the Teton Sioux—September 26, 1804"
36" x 54" oil on canvas

"At dusk, Clark and Lewis were carried with much ceremony on a decorated buffalo robe to the great council lodge in the middle of the village. Fires glowed through translucent tepees as the women prepared a feast. Slabs of buffalo meat roasted over hot coals. Inside the council lodge, seventy elders and prominent warriors sat in a circle. The Americans sat beside Black Buffalo. In front of them a six-foot sacred circle had been cleared for holy pipes, pipe stands, and medicine bundles."

— STEPHEN E. AMBROSE, *UNDAUNTED COURAGE*, PP. 172–173

Perhaps the moments of highest drama during the entire Lewis and Clark Expedition occurred in the last days of September 1804. Tensions ebbed and flowed over the course of five days. At one critical point on September 25, hostilities nearly broke out at the river's edge. At other times, as on the evening of September 26, ceremony and cordiality prevailed as the Captains and the Chiefs attempted to negotiate and understand one another inside a huge council lodge. During this time the Captains fell victim to their own confidence. Their minimal understanding of the tribal dynamics on the northern plains caused them to inadvertently promote trade proposals that were threatening to the Teton Sioux. They were the most powerful tribe of the region and were able to control the flow of trade goods for their benefit. St. Louis traders referred to the Teton Sioux as the "Pirates of the Missouri." Confronted now with Captain Lewis's proposal of peaceful trading with all tribes, the Teton Sioux felt their dominant position was in jeopardy.

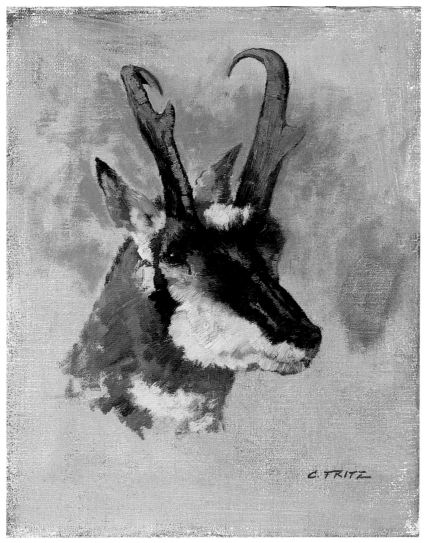

"The Pronghorned Goat"
10" x 8" oil on canvas

"…in short they will frequently discover and flee from you at the distance of three miles. I had this day an opportunity to witnessing the agility and superior fleetness of this anamal which was to me really astonishing…I made the best of my way towards them, frequently peeping over the ridge with which I took care to conceal myself from their view…I got within about 200 paces of them when they smelt me and fled; I gained the top of the eminece on which they stood, as soon as possible from whence I had an extensive view of the country the antilopes which had disappeared in a steep revesne now appeared at the distance of about three miles on the side of a ridge…I doubted at ferst that they were the same that I had just surprised, but my doubts soon vanished when I beheld the rapidity of their flight along the ridge it appeared reather the rappid flight of birds than the motion of quadrupeds."

— CAPTAIN MERIWETHER LEWIS, SEPTEMBER 17, 1804

"Abandoned Indian Village, Upper Missouri River"
10" x 15" oil on board

"…I saw an old remains of a villige on the Side of a hill which the Chief with us Too né tels me that nation [Mandans] lived in…a number of villages on each Side of the river and the Troubleson Seauex caused them to move about 40 miles higher up where they remained a fiew years & and moved to the place they now live…"
— CAPTAIN WILLIAM CLARK, OCTOBER 20, 1804

During these days of autumn, the Corps was passing numerous old Indian villages. These villages, abandoned in the early 1790s, had deteriorated to the point that Captain Clark noted they *"appear to have been fortified."* It was common for the villages of these early farming cultures to excavate a trench and then fortify the trench against enemies with a wall of logs gathered from the surrounding river bottoms. The circular homes of the Mandans needed to be rebuilt about every five years, as human occupancy, horses, and weather wore down the wood and dirt structures. When the residents abandoned the village, it is likely they took as much of the key building materials with them as possible. This village probably had been left to the elements for fifteen years before the Corps came upon it that day in October.

"The Discussion"
24" x 16" oil on board

"wind hard from the west Commence building our Cabins, Dispatched 6 hunters in a perogue Down the River to hunt, Discharged the french hands, Mr. Jessomme his Squar & child moved to camp…"
— CAPTAIN WILLIAM CLARK, NOVEMBER 3, 1804

The Expedition's composition evolved during the winter at Fort Mandan. The previous winter in St. Louis and at Wood's River, the Captains had hired experienced French boatmen, called "voyageurs" or "engagés," to aid the Corps in ascending the Missouri. Upon reaching the Knife River villages, their skills were no longer needed and, as was common protocol for the time, they were discharged from service. The voyageurs, now free to do as they willed until spring, built a hut outside the walls of Fort Mandan to wait out the winter and enjoy the company of the Mandans.

The Captains hired two interpreters who were living at the villages. Both René Jusseaume and Toussaint Charbonneau were known for their questionable character, but during the coming year, the Captains would need their experience and knowledge of native languages. Along with their Indian wives, the interpreters moved into lodges outside the walls of Fort Mandan.

"The Mandan Buffalo Hunt—December 7, 1804"
36" x 60" oil on canvas

"A clear cold morning…Big-white…came to our garrison and told us that the buffaloe were in the prairie coming into the bottom. Captain Lewis and eleven more of us went out immediately, and saw the prairie covered with buffaloe and the Indians on horseback killing them…They shoot them with bows and arrows, and have their horses so trained that they will advance very near and suddenly wheel and fly off in case the wounded buffaloe attempt an attack."

— SERGEANT PATRICK GASS, DECEMBER 7, 1804

"Bartering for Corn, Interior of Fort Mandan"
10" x 18" oil on canvas

"…we are now burning a large Coal pit, to mend the indians hatchets, & make them war axes, the only means by which we precure Corn from them—"
— CAPTAIN WILLIAM CLARK, JANUARY 29, 1805

"the blacksmiths take a considerable quantity of corn today in payment for their labour. the blacksmith's have proved a happy resoce to us in our present situation as I believe it would have been difficult to have devised any other method to have procured corn from the natives. the Indians are extravegantly fond of sheet iron of which they form arrow-points and manufacter into instruments for scraping and dressing their buffaloe robes—"
— CAPTAIN MERIWETHER LEWIS, FEBRUARY 6, 1805

To supplement their diet of lean meat, the men needed to acquire some of the Mandans' surplus corn and vegetables. The blacksmithing talents of Private John Shields became the commodity the Corps could offer in exchange for Mandan corn. From earlier trading with the French, the Mandans had acquired a few guns and some metal tools, many of which had broken or become dull. Private Shields initially repaired and sharpened those items, and later, when business slowed, he began fabricating a style of tomahawk head that became particularly popular with the Indians. In this painting, the interpreter Charbonneau is shown adamantly requesting a higher price for Private Shields's services.

"Our Boats, Gripped in Ice"
8" x 16" oil on board

"the situation of our boat and perogues is now allarming, they are firmly inclosed in the Ice and almost covered with snow."
— CAPTAIN MERIWETHER LEWIS, FEBRUARY 3, 1805

"All hands employed in Cutting the Perogus Loose from the ice, which was nearly even with their top; we found great difficuelty in effecting this work owing to the Different devisions of Ice & water after Cutting as much as we Could with axes, we had all the Iron we Could get & Some axes put on long poles and picked throught the ice…"
— CAPTAIN WILLIAM CLARK, FEBRUARY 23, 1805

Both this and the following painting, "Study for Mapping the Missouri," are small studies done on location, leading up to the larger work titled "Mapping the Missouri: Winter Afternoon at Fort Mandan," on page 52. Note the elements in both of these preliminary studies that appear in the final effort.

"Study for Mapping the Missouri"
10" x 15" oil on board

"we fixed a Windlass and Drew up the two Perogues on the upper bank and attempted the Boat, but the Roap which we hade made of Elk Skins proved too weak & broke Several times…"

— CAPTAIN WILLIAM CLARK, FEBRUARY 25, 1805

"Drew up the Boat & perogus, after Cutting them out of the ice with great Dificuelty—& trouble"

— CAPTAIN WILLIAM CLARK, FEBRUARY 26, 1805

"Mapping the Missouri: Winter Afternoon at Fort Mandan"
36" x 58" oil on canvas

"a cold day Some Snow, Several Indians visit us…I imploy my Self drawing a Connection of the Countrey from what information I have recved—"
— CAPTAIN WILLIAM CLARK, JANUARY 5, 1805

The five months the Corps spent with the Mandans and Hidatsas in the winter of 1804 to 1805 were eventful, successful, and memorable in many ways. When the Corps arrived, they found 4,500 inhabitants in the Knife River villages, a greater number than in Washington, D.C. The Mandans in particular were gracious neighbors and hosts. Frequent and friendly exchange of hospitalities by both the natives and the military residents of Fort Mandan helped the Corps survive what otherwise would have been a very difficult winter. Holidays, ceremonies, information, hunting trips, food, medicine, daily news, the warmth of human relationships, and optimistic plans for future trade were all shared during that winter on the Upper Missouri.

"Captain Clark's Hunting Party Departing"
8" x 16" oil on board

"This morning fair tho' could the thermometer stood at 18° below Naught, wind from N. W. Capt Clark set out with a hunting party consisting of sixteen of our command and two frenchmen…The men transported their baggage on a couple of small wooden Slays drawn by themselves, and took with them 3 pack horses which we had agreed should be returned with a load of meat to fort mandane as soon as they could procure it. no buffaloe have made their appearance in our neighbourhood for some weeks…"
— CAPTAIN MERIWETHER LEWIS, FEBRUARY 4, 1805

Captain Clark and his party went out hunting for nine days, traveling as far as sixty miles south of Fort Mandan, into the vicinity of today's Bismarck, North Dakota. The hunt was typically arduous, with great distances being walked in bitter cold and wind; one of Joseph Field's ears froze.

"Nightfall in a Mandan Village"
12" x 16" oil on canvas mounted on board

"…found their lodges in this village about 60 in nomber and verry close compact. in a round form large & warm covered first after the wood is willows and Grass. Then a thick coat of Earth…except the chimney hole which Goes out at center & top." — SERGEANT JOHN ORDWAY, OCTOBER 10, 1804

"last night was excessively Cold the murkery this morning Stood at 40° below 0 which is 72° below the freesing point…" — CAPTAIN WILLIAM CLARK, JANUARY 10, 1805

"The Indians are invariably severe riders, and frequently…for many days together through the whole course of the day… employ their horses in pursuing the Buffaloe or transporting meat to their vilages during which time they are seldom suffered to tast food; at night the Horse returned to his stall where his food is what seems to me a scanty allowance of wood. under these circumstances it would seem that their horses could not long exist or at least could not retain their flesh and strength, but the contrary is the fact, this valuable anamall under all those disadvantages is seldom seen meager of unfit for service." — CAPTAIN MERIWETHER LEWIS, FEBRUARY 12, 1805

"Winter Sun on the Knife River"
10" x 12" oil on board

Typically the earthlodge villages were the summer residences of the Mandans and Hidatsas. In the winter they would move into hide lodges in the protected river bottoms, close to firewood and out of the constant winter winds. During the period of the Expedition's visit, the tribes, weakened by smallpox, were staying in their earthlodge villages through the winter. The protection of the palisades and the elevated sites offered increased defense against the marauding Sioux. Inside the doorway of the earthlodges were stalls where the most valuable horses could be kept safe through the night. It was here that they were given their feed ration: branches and bark of the cottonwood.

"Burial of a Buffalo Bull Society Warrior"
10" x 18" oil on board

"…the form of these Savvages burrying their dead is after they have disceased they fix a Scaffel on & raised 4 forks abt 8 or 10 feet from the Ground. they lye the dead body on the Sd. Scaffel Raped up in a Buffalow Robe a little distance from their villages—their villages are close compact & picketed in. when any of them loose a partickulor friend or relation they morn and cry for Some time after."

— SERGEANT JOHN ORDWAY, OCTOBER 28, 1804

Sergeant Ordway's valuable ability to note the commonplace gives us many glimpses into the life and environment of the native peoples. He was keenly observant, and in this instance he gives us our best insight into the burial practices of these Upper Missouri River inhabitants.

The Buffalo Bull Society was reserved for only the bravest of Mandan warriors. Sergeant Gass wrote on October 27: *"These people do not bury their dead, but place the body on a scaffold, wrapped in a buffaloe robe, where it lies exposed."*

"Our Shelter at Canoe Camp"
10" x 15" oil on board

"the perogue men got their axes repaired and drew two days provisions and went up to camp out near their work untill they Git it done or Git the 4 perogues completed."

— SERGEANT JOHN ORDWAY, MARCH 1, 1805

As spring arrived, the men grew impatient and wanted to proceed on. They were eager to perform the tasks necessary to get back on the river. In late February and early March, crews were sent five miles north of Fort Mandan, where large cottonwood trees could be used to construct the dugout canoes that would be needed to replace the keelboat, which was too large to continue up the Missouri; it would return to St. Louis with its load of gathered specimens and ethnological material.

"March Break-up"
6" x 8" oil on board

"a find Day wind S.W. but fiew Inds visit us to day the Ice haveing broken up in Several places, The ice began to brake away this evening and was near distroying our Canoes as they wer decnding to the fort, river rose only 9 Inches to day prepareing to Depart"

— CAPTAIN WILLIAM CLARK, MARCH 25, 1805

The ice on the Missouri River was beginning to break up, and canoes were brought down from the canoe camp, where they had been built. As the river began to flow again, the Corps observed the Mandans snagging dead bison floating by in the river. On March 28, 1805, Captain Clark recorded, *"but few Indians visit us to day they are watching to catch the floating Buffalow which brake through the ice in Crossing, those people are fond of those animals ta[i]nted and Catch great numbers every Spring."*

On April 7, 1805, the Expedition's permanent party of thirty–three was ready to press on into the wilderness in their two pirogues and six new canoes; the keelboat and crew returned to St. Louis.

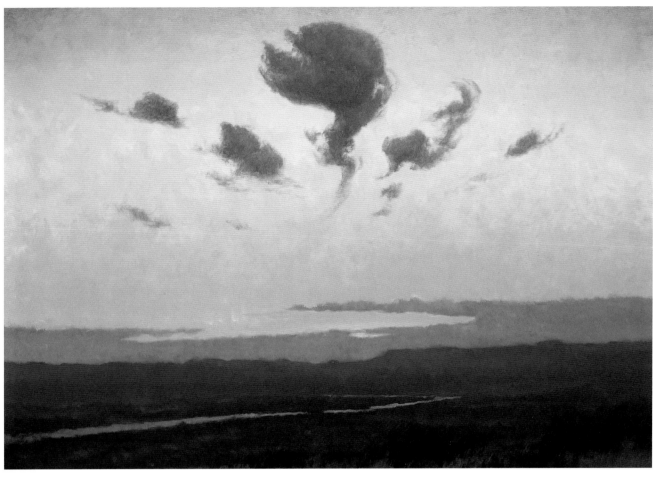

"The Ancient River"
32" x 46" oil on board

"I observe a great alteration in the Current course and appearance of this pt. of the Missouri. in places where there was Sand bars in the fall 1804 at this time the main Current passes, and where the current then passed in now a Sand bar—Sand bars which were then naked are now covered with willow Several feet hight. the enteranc of Some of the Rivers & Creeks Changed owing to the mud thrown into them, and a layor of mud over Some of the bottoms of 8 inches thick."

— CAPTAIN WILLIAM CLARK, AUGUST 20, 1806

For perhaps millions of years, the ancestral Missouri River flowed north to empty its great volume into what is now Hudson Bay. Then, only 2 million years ago during the Pleistocene Ice Age, advancing sheets of continental glaciers scoured the northern land-scape, damming the river's northerly flow and forcing it to the southeast and the Gulf of Mexico. Captain Clark's astute observations over the two–year period from 1804 to 1806, though astounding, represent just a brief moment in the dynamic geologic life of the Missouri River. Although the surrounding landscape attempts to confine the river within its narrow banks, the river, made powerful by the water drained from 500,000 square miles, accepts no boundaries and braids its channels at will.

"Study for the River Rochejhone"
10" x 18" oil on board

"The Rochejhone Confluence"
10" x 18" oil on board

In April of 1805, when the Expedition arrived at the Yellowstone River's confluence with the Missouri, the Yellowstone was known by several names with a variety of spellings. The Indians called it Elk River; the earliest French voyageurs, ahead of Lewis and Clark, referred to it as la Roche Jaune, which means the "Yellow Rock." The Captains used both of these names, as well as the English Yellow Stone, in the Journals.

In the upper left portion of this painting, the Yellowstone River enters from the south and meets with the Missouri River. In 1828 the north bank of the Missouri would become the site of the fur trading post Fort Union.

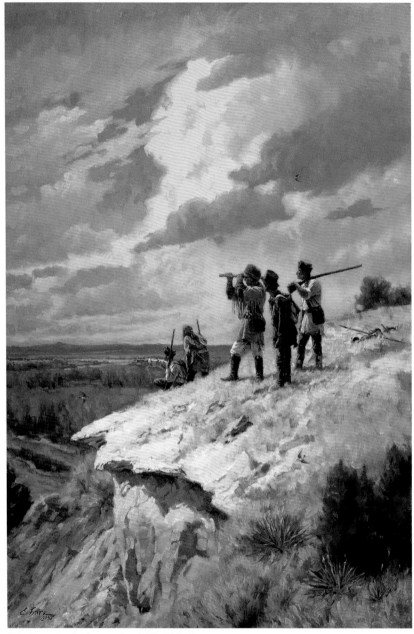

"The River Rochejhone—April 25, 1805"

36" x 24" oil on canvas

"…I ascended the hills from whence I had a most pleasing view of the country, perticularly of the wide and fertile vallies formed by the missouri and the yellowstone rivers, which occasionally unmasked by the wood on their borders disclose their meanderings for many miles in their passage through these delightfull tracts of country. the whol face of the country was covered with herds of Buffaloe, Elk & Antelopes; deer are also abundant…"
— CAPTAIN MERIWETHER LEWIS, APRIL 25, 1805

On this April afternoon from a high bluff on the south bank of the Missouri, they made their first sighting of the Yellowstone River, an important milestone on their westward trek.

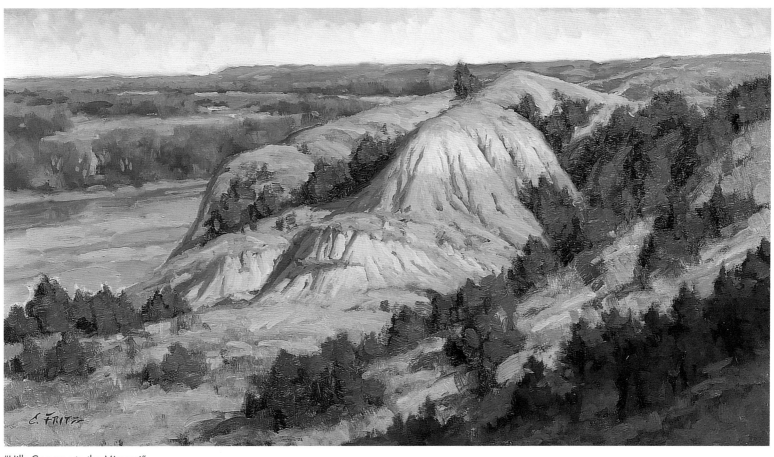

"Hills Common to the Missouri"
10" x 18" oil on board

"…2 Small runs fall in on the S. Side and one this evening on the Lard Side those runs head at a fiew miles in the hills and discharge but little water, the Bluffs in this part as also below Shew different Staturs of Coal or carbonated wood, and Coloured earth, such as dark brown, yellow a lightish brown, & a dark red &c."
— CAPTAIN WILLIAM CLARK, APRIL 28, 1805

DETAIL:
"The River Rochejhone—April 25, 1805"

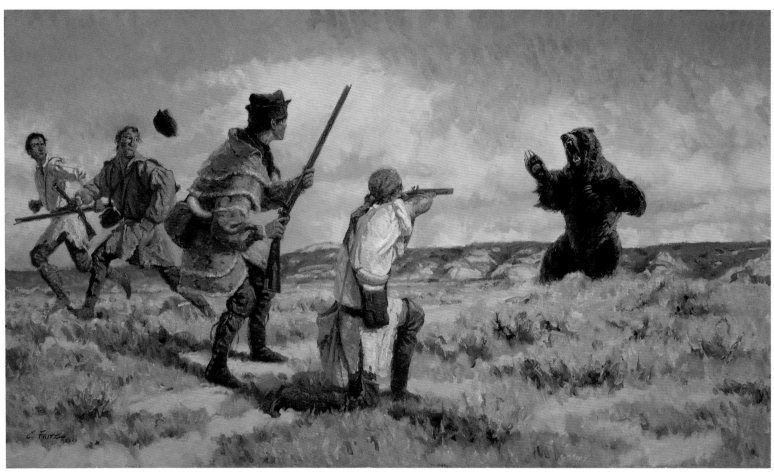

"In an Instant the Monster Ran at Us…"

22" x 38" oil on canvas

"In the evening the men in two of the rear canoes discovered a large brown bear lying in the open…six of them went out to attack him, all good hunters; they took the advantage of a small eminence which concealed them and got within 40 paces of him unperceived, two of them reserved their fires…the four others fired nearly at the same time and put each his bullet through him…in an instant this monster ran at them with open mouth, the two who had reserved their fires discharged their pieces at him as he came towards them…the men unable to reload their guns took to flight…"

— CAPTAIN MERIWETHER LEWIS, MAY 14, 1805

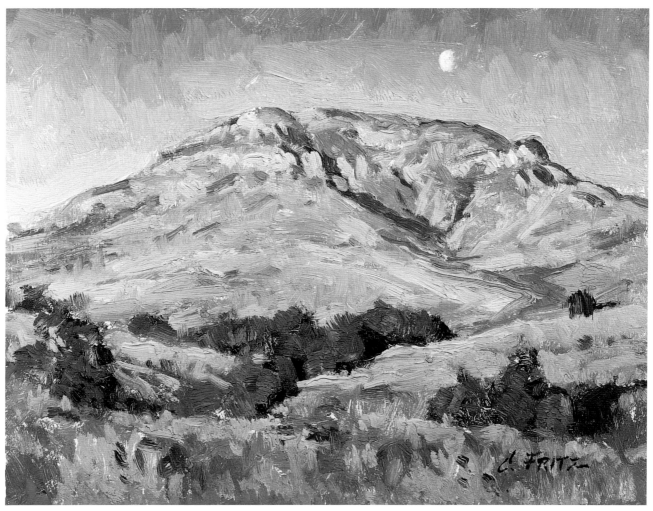

"Prairie Moonrise"
6" x 8" oil on board

It was the Mandan Indians who first told the Corps about the *"horrible bear"* that lived out on the plains. Lewis boasted in journal entries that *"the men as well as ourselves are anxious to meet with some of these bear. the Indians give a very formidable account of the strengh and ferocity of this anamal…the savages attack this anamal with their bows and arrows and the indifferent guns which the traders furnish them…this anamall is said more frequently to attack a man on meeting with him, than to flee from him…but in the hands of skillfull riflemen they are by no means as formidable or dangerous as they have been represented."*

It did not take long, nor very many encounters with the bear, before the men's opinion of this large prairie carnivore changed. On May 5, 1805, Clark wrote, *"we Saw a Brown or Grisley beare on a Sand beech, I went out with one man…and Killed the bear, which was verry large and a turrible looking animal, which we found verry hard to kill…This animal is the largest of the Carnivorous kind I ever Saw.…"* With many grizzly bear encounters still to come, the men had begun to adopt the same respect for the bears that the Indians had shown earlier. Humorously, Lewis showed how much his view had evolved when he summarized on May 6, 1805,
"I find that the curiossity of our party is pretty well satisfyed with rispect to this anamal.…"

"Cliffs above Burnt Lodge Creek"
10" x 12" oil on board

"The country rugged, the hills high, their summits and sides partially covered with pine and cedar, and the river on either side washing their bases. it is somewhat singular that the lower part of these hills appear to be formed of a dark rich loam while the upper region about 150 feet is formed of a whiteish brown sand, so hard in many parts as to resemble stone…"

— CAPTAIN MERIWETHER LEWIS, MAY 17, 1805

"we were roused late at night and warned of the danger of fire from a tree which had Cought and leaned over our Lodge, we had the lodge moved Soon after the Dry limbs & top of the tree fell in the place the Lodge Stood, the wind blew hard and the dry wood Cought & fire flew in every direction, burnt our Lodge verry much from the Coals which fell on it altho at Some distance in the plain, the whole party was much disturbed by this fire which could not be extinguished &c"

— CAPTAIN WILLIAM CLARK, MAY 17, 1805

This painting was done about one mile up Burnt Lodge Creek where layers of ancient sea beds are now exposed. Captain Clark observed a fortified Indian camp at the mouth of Burnt Lodge Creek, which he suspected was that of a Minitari (Atsina) war party that had left the Knife River villages in early spring. In the following decades, Burnt Lodge Creek continued to be the stage on which Western history and legends would play out. Home-steaders departed the steamboats here to begin their hard lives on the dry plains, bone gatherers carved wagon trails up the coulees, and Jim Bridger, Jedediah Smith, and Kid Curry all roamed the region. It was the capture and hanging of seven Blackfeet Indians suspected of stealing horses that earned the creek its name on modern maps, Seven Blackfoot.

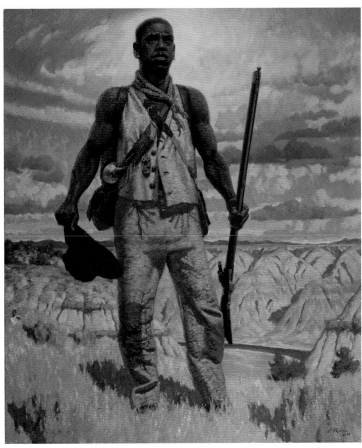

"Glimpsing Freedom: York's Journey with the Corps of Discovery"
38" x 32" oil on canvas

"This day we saw several gangs or herds, of buffaloe on the sides of the hills: One of our hunters killed one, and Captain Clarke's black servant killed two."
— SERGEANT PATRICK GASS, SEPTEMBER 9, 1804

"…the Indians much asstonished at my Black Servent and Call him the big medison, this nation never Saw a black man before…Canoos of Skins passed down from the 2 villages a Short distance above, and many Came to view us all day, much asstonished at my black Servent, who did not lose the oppertunity of his powers Strength &c…this nation never Saw a black man before."
— CAPTAIN WILLIAM CLARK, OCTOBER 9, 1804

"…Captain Clark, 3 of the party, & his black Servant, left us, and set out one days travel, up the River by land to make discoveries."
— PRIVATE JOSEPH WHITEHOUSE, JULY 18, 1805

To impress the Indian tribes, Lewis and Clark brought along magnets, compasses, a silent air-gun, and common trade items. They did not anticipate that one of the Indians' greatest curiosities would be York, Captain Clark's black slave, whom the Arikaras called Big Medicine. The tribes reacted to York in various ways, but the presence of this powerful, dark-skinned man always seemed to help further the Corps's objectives.

Thirty-three travelers journeyed to the Pacific Ocean and back. Of them all, York is the one who remains most shrouded in mystery. York's biographer, Robert Betts, ends the decades of superficial research about York in his 1985 book, *In Search of York*, in which he sheds light on this remarkable historical figure and encourages us to give greater consideration to this intriguing member of the Expedition.

Crossing the continent with such a small contingent of men required a high level of service from each member. Just as the enlisted men, York was expected to make independent decisions and accomplish assigned duties. He had his own firearm, he hunted regularly, and if attacked he surely would have helped to defend the party. During the torturous storms on the Pacific Coast, York's vote was counted equally with the others regarding their decision on where to spend the winter.

In the far reaches of the Louisiana Territory, this slave experienced an uncommon level of personal freedom and social value that never would have been possible in the South. Like the young nation it represented, the Corps of Discovery attained greater success because of its unintentional diversity. More than six decades would pass before the Civil War emancipated the slaves and the Fifteenth Amendment granted African American men the right to vote, but out on the vast western prairie, on the Lewis and Clark Expedition, a slave named York glimpsed the future.

"High Wall on the Upper Missouri"
10" x 20" oil on board

Lewis and Clark did not name this large rock feature. The only specific mention of it in the Journals is under *"Courses and distances of May 31, 1805."* Noted only as *"a high wall of black rock,"* this formation later became well known to all travelers on the Upper Missouri River. It was known as Citadel Rock to trappers, keelboaters, and later to the steamship captains. Karl Bodmer painted his romantic version of the famous landmark in 1833 while on expedition with Prince Maximilian of Austria.

"Massive Rock, White Cliffs"
6" x 8" oil on board

"in maney places of this days march we observe on either Side of the river extraodanary walls of a black Semented stone…Some of those walls run to the hite of 100 feet…and are perpendicular…"
— CAPTAIN WILLIAM CLARK, MAY 31, 1805

Throughout the White Cliffs region, "dikes" of igneous rock jut out of the landscape, slicing through the vertical cliffs and running across the prairie like giant knife blades. In the decades following the Expedition, the striking presence of these intrusions would earn them notable names as fur traders and others plied the river. This massive rock, near Eagle Creek, was named LaBarge Rock after the famous steamboat captain Joseph LaBarge.

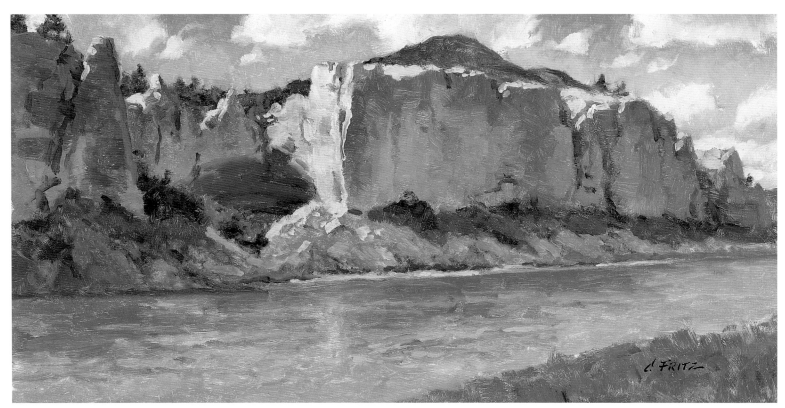

"The White Cliffs at Stonewall Creek"
10" x 20" oil on board

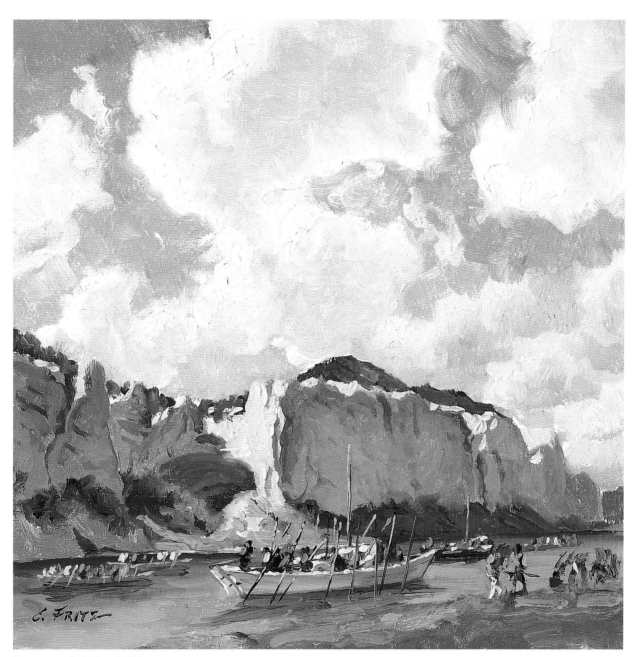

"Canoes at the White Cliffs"

8" x 8" oil on board

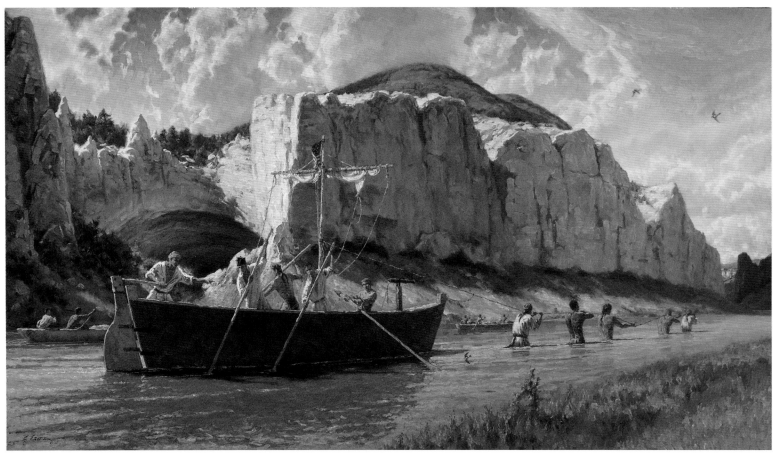

"Cordelling the Red Pirogue, White Cliffs of the Missouri—May 31, 1805"
36" x 64" oil on canvas

"The obstructions of rocky points and riffles still continue as yesterday; at those places the men are compelled to be in the water even to their armpits, and the water is yet very could, and so frequent are those point that they are one fourth of their time in the water..."

— CAPTAIN MERIWETHER LEWIS, MAY 31, 1805

"the tow rope of the white perogue which we were oblidge to make use of broke & was in Some danger of turning over....we are oblidged to undergo great labour and fatigue in ascending this part of the Missourie as they are compelled from the rapidity of the current in many places to walk in the...Stiff mud, bear footed & we cannot keep on moccasons from the Stiffness of the mud & decline of the Steepp hill sides—"

— SERGEANT JOHN ORDWAY, MAY 31, 1805

"Dikes and Cliffs along Stonewall Creek"
10" x 20" oil on board

It is hard for modern travelers to comprehend the toll that the Missouri River took on those who ascended it in the 1800s. Students of Lewis and Clark and the ensuing fur trade ponder with amazement the thought of propelling the large, heavy boats up the rivers of the West. There were four methods of locomotion and none of them were very appealing: paddling, poling, sailing, and cordelling (the practice of tying a long rope to the mast of the keelboat and pulling the craft upstream either from the shore or shallow water).

The paintings of Karl Bodmer, done in the 1830s, show us the nature of the Missouri River before dams, when the river ran wild and channels braided back and forth through each other. Cottonwood trees eroded from the river's banks and floated and tumbled downstream until they eventually silted into the river bottom. Called sawyers—after the men who made their living cutting timber—these trees made the river even more treacherous, their submersed branches reaching up like evil, groping fingers threatening to upset a boat that accidentally drifted into them or snagging and drowning anyone who was unfortunate enough to be swept into one. It was as though the river had decided to defend itself from any human advance.

The Captains were astounded at the black rock intrusions found at the White Cliffs. Their descriptions are long and appreciative of the marvels they passed by on May 31, 1805. In describing the intrusions, Lewis wrote: *"These walls rise to the hight in many places of 100 feet, are perpendicular, with two regular faces and are from one to 12 feet thick, each wall retains the same thickness at top which it possesses at bottom."* Further on he continues: *"These walls pass the river in several places, rising from the water's edge much above the sandstone bluffs, which they seem to penetrate; thence continuing their course on a streight line on either side of the river through the gradually ascending plains…"* Today Stonewall Creek is known as Eagle Creek.

"Dusk—May 31, 1805"

6" x 8" oil on board

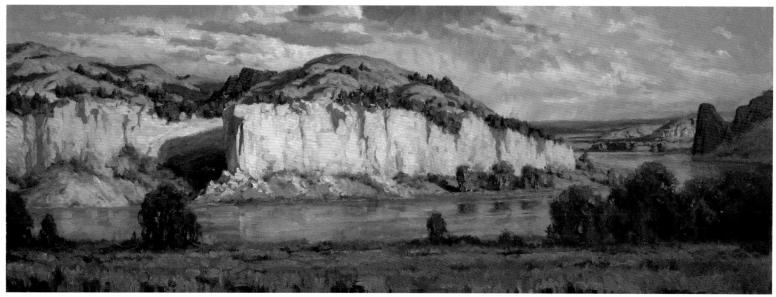

"Morning Light, White Cliffs of the Upper Missouri"
16" x 44" oil on canvas

"As for the White Cliffs themselves, Lewis's description is one of the classics of American travel literature...."
— STEPHEN E. AMBROSE, *UNDAUNTED COURAGE*, P. 228

"The hills and river Clifts which we passed today exhibit a most romantic appearance. The bluffs of the river rise to the hight of from 2 to 300 feet and in most places nearly perpendicular...The water in the course of time in decending from those hills...has trickled down the soft sand clifts and woarn it into a thousand grotesque figures, which with the help of a little immagination and an oblique view...are made to represent eligant ranges of lofty freestone buildings...stocked with statuary...long galleries...the remains or ruins of eligant buildings...some collumns standing...some lying prostrate an broken...nitches and alcoves of various forms and sizes...so perfect indeed...that I should have thought that nature had attempted here to rival the human art of masonry had I not recollected that she had first began her work."
— CAPTAIN MERIWETHER LEWIS, MAY 31, 1805

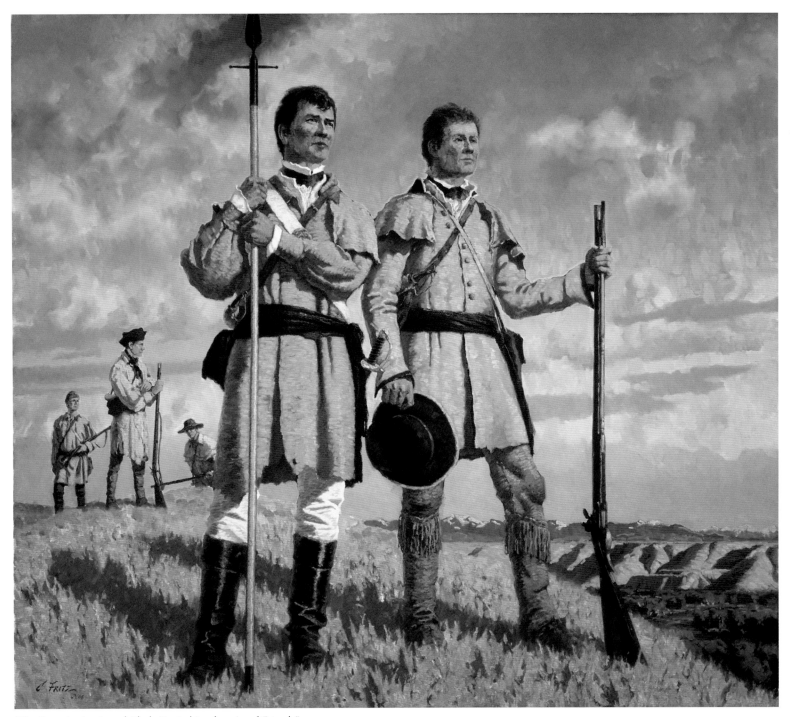

"The Captains Lewis and Clark: Trusted Leaders, Loyal Friends"

44" x 50" oil on canvas

"Thus my friend you have…a summary view of the plan, the means and the objects of this expedition. If therefore there is anything under those circumstances, in this enterprise, which would induce you to participate with me in it's fatiegues, it's dangers and it's honors, believe me there is no man on earth with whom I should feel equal pleasure in sharing them as with yourself…He [Jefferson] has authorized me to say that in the event of your accepting this proposition he will grant you a Captain's commission which of course will intitle you to the pay and emoluments attached to that office…your situation if joined with me in this mission will in all respects be precisely such as my own…I should be extremely happy in your company…" — FROM CAPTAIN LEWIS'S LETTER OF INVITATION TO WILLIAM CLARK, JUNE 19, 1803

"This is an undertaking fraited with many difeculties, but My friend I do assure you that no man lives with whome I would perfur to undertake Such a Trip &c. as your self…" — FROM WILLIAM CLARK'S LETTER OF ACCEPTANCE, JULY 18, 1803

During a six-month period in 1796, eight years before the Expedition, the then Ensign Meriwether Lewis was put under the command of the then Lieutenant William Clark at Fort Greenville on the Ohio frontier. Clark was four years older than Lewis, but the two young officers took an immediate liking to one another. They became very good friends and continued to correspond in the years after Clark left the military. In 1803, when Thomas Jefferson and the now Captain Lewis pondered likely candidates for an officer to accompany Lewis on the Expedition, William Clark quickly rose to the top of the list. Clark was to be reinstated as a Captain and serve beside Lewis as co-leader of the Expedition, an arrangement generally fraught with the potential for strife and conflict. However, these two friends seemed to know they would make a strong team. Absent were envy and jealousy; rather each had great admiration for the strengths and finer qualities found in the other. Captains Lewis and Clark truly were *"Trusted Leaders and Loyal Friends."*

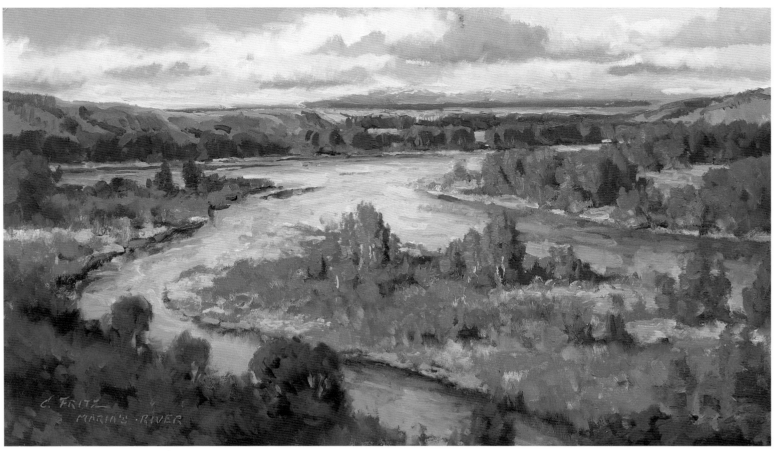

"View over Maria's River"
10" x 18" oil on board

After naming Maria's River (known as the Marias River today) in honor of his cousin Maria Wood, Lewis wrote, *"it is a noble river; one destined to become in my opinion an object of contention between the two great powers of America and Great Britin…"*

— CAPTAIN MERIWETHER LEWIS, JUNE 8, 1805

When the Corps reached the Marias River on June 3, they were faced with circumstances for which the Mandans had not prepared them. Here was a fork, each river of sufficient size and flow to be the true Missouri. Choosing the correct fork was immensely important; the loss of days or weeks could jeopardize the entire Expedition. Pulling the boats up the wrong fork also would be a costly waste of the men's energy, and it was essential that the men had enough stamina left to cross over the mountains during that summer season.

The Captains believed the south fork was the true Missouri River; the men felt they should take the north fork. After six days of reconnoitering and deductive reasoning, the Captains concluded that the south fork was indeed the true Missouri. It was a testament to the men's faith in their Captains when they *"said very cheerfully that they were ready to follow us any wher we thought proper…but that they still thought that the* [north fork] *was the river…"* One week later, the men's trust in their Captains would be vindicated when the Corps reached the magnificent Great Falls, a landmark the Mandans had told them they would see.

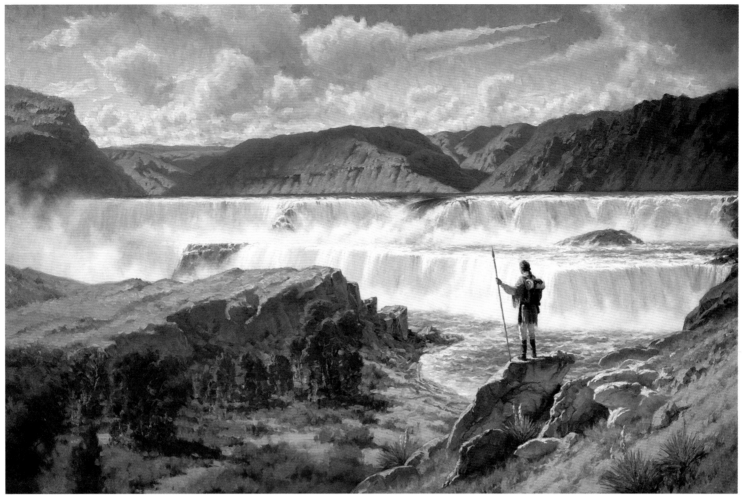

"The Arrival of Captain Lewis at the Great Falls of the Missouri—June 13, 1805"

42" x 65" oil on canvas

"...I wished for the pencil of Salvator Rosa or the pen of Thompson, that I might be enabled to give to the enlightened world some just idea of this truly magnifficent and sublimely grand object..."

— CAPTAIN MERIWETHER LEWIS, JUNE 13, 1805

Astounded at the sight of the Great Falls, Captain Lewis was, at this moment, enthralled with this *"grand object."* Unaware of the impact this obstacle was to have on the Expedition, he wrote an extensive journal entry expressing his awe and wonder and deep appreciation for this gift of nature. His desire to adequately show the grandeur of the falls was frustrated by the lack of a camera obscura, or an artist such as Salvator Rosa, or the gifted "pen" of poet James Thomson. In his exasperation to properly capture the Great Falls, he attempted his own sketch. *"...I therefore with the assistance of my pen only indeavoured to trace some of the stronger features of this seen..."* Unfortunately, this precious sketch by Captain Lewis is lost to history. From the descriptions given to them at the Knife River villages during the winter, the Captains had scheduled half a day for portaging around the Great Falls. Instead, it took them four weeks of toil to avoid the series of five waterfalls.

"Crooked Falls"
10" x 12" oil on board

"The Cascade of Crooked Falls"
10" x 28" oil on board

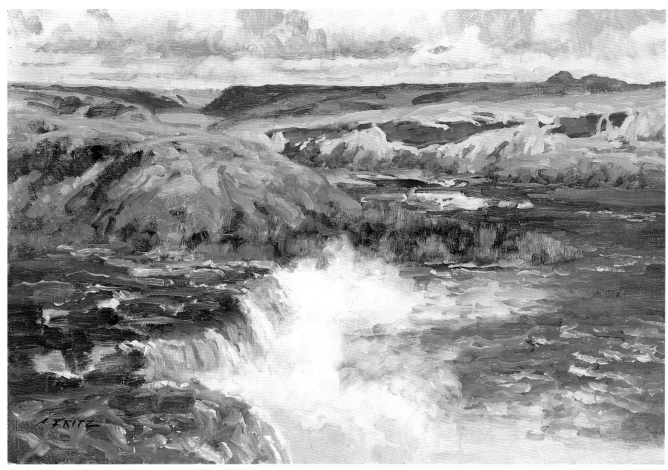

"Handsome Falls—June 14, 1805"
10" x 15" oil on board

"I should have returned from hence but hearing a tremendious roaring above me I continued my rout… and was again presented by one of the most beatifull objects in nature…the water decends in one even and uninterupted sheet to the bottom wher dashing against the rocky bottom rises into foaming billows of great hight and rappidly glides away, hising flashing and sparkling as it departs…I now thought that if a skillfull painter had been asked to make a beautifull cascade that he would most probably have pesented the precise immage of this one…" — CAPTAIN MERIWETHER LEWIS, JUNE 14, 1805

Captain Lewis's trek on this day brought about mixed feelings—his awe of the area's beauty was tempered by the realization that the short portage the Corps had planned around the Great Falls was not to be. On this day, Lewis encountered a "tiger" cat (wolverine), an enraged grizzly bear, and three charging bison bulls. That night he wrote: *"It now seemed to me that all the beasts of the neighbourhood had made a league to distroy me, or that some fortune was disposed to amuse herself at my expence…."*

Handsome Falls was one of five waterfalls that would require an eighteen-mile portage. It caused an extensive delay of almost a month for the Corps of Discovery. Today these falls are known as Rainbow Falls.

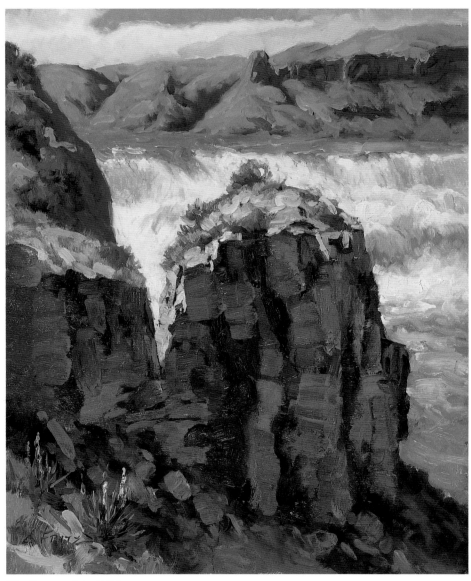

"The Canyon of the Falls"
12" x 10" oil on board

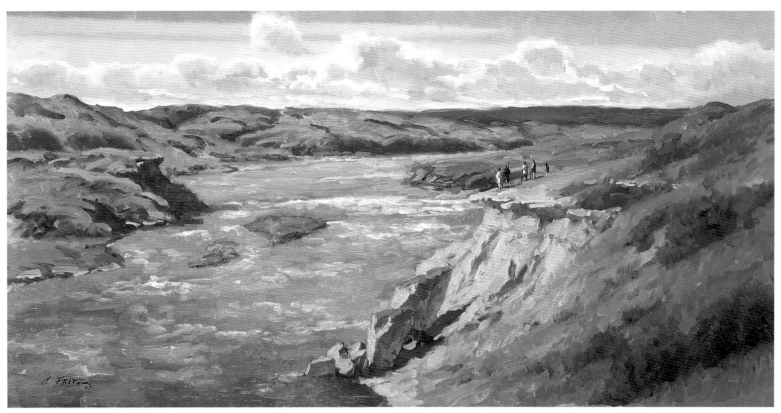

"View of the Missouri near Portage Camp"
10" x 20" oil on board

"This morning at sunrise I dispatched Joseph Fields with a letter to Capt. Clark and ordered him to keep sufficiently near the river to observe it's situation in order that he might be enabled to give Capt. Clark an idea of the point at which it would be best to halt to make our portage."
— CAPTAIN MERIWETHER LEWIS, JUNE 14, 1805

This painting, done on the north side of the Missouri River, is looking west toward the series of falls. Across the river, on the south side, was the location of the Lower Camp. Upstream, at the mouth of Portage Creek (today's Belt Creek), the Corps found access to the plains and a strenuous portage to the Upper Camp on White Bear Island.

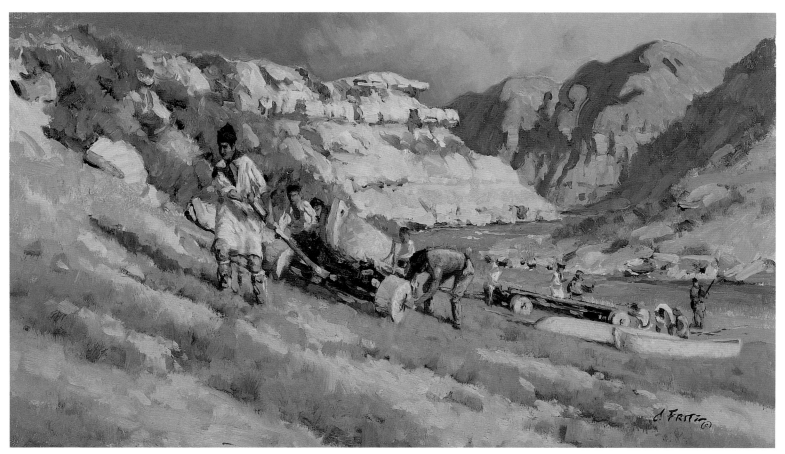

"Where Our Portage Began"
10" x 18" oil on board

The men paddled and pushed the heavy dugout canoes south almost two miles up Portage Creek. At this point, the Corps arrived at a sloping hillside, which led to the undulating plains. Once on top, they connected to Captain Clark's chosen route to White Bear Island.

"Storm over the Portage Route"

6" x 8" oil on board

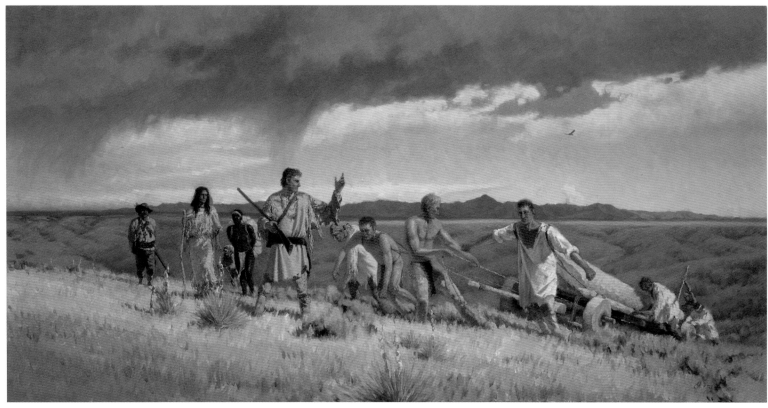

"The Corps of Discovery's Portage around the Great Falls of the Missouri—June 1805"
30" x 60" oil on canvas

"...the men has to haul with all their Strength wate & art, maney times every man all catching the grass & knobes & Stones with their hands to give them more force in drawing on the Canoes & Loads, and notwithstanding the Coolness of the air in high presperation and every halt, those not employed in reparing the Couse; are asleep in a moment, maney limping from the Soreness of their feet Some become fant for a fiew moments, but no man Complains all go Chearfully on—"

— CAPTAIN WILLIAM CLARK, JUNE 23, 1805

The portage of the Great Falls by the Corps of Discovery was a test of courage and perseverance. Nature and conditions pressed against the men's progress in every way. Six heavy canoes and the baggage of an expedition had to be moved cross-country on crude wooden carts; the wheels, cut from the largest tree that could be found on the otherwise treeless plains, were just twenty-two inches in diameter. On the morning of June 28, Captain Clark dispatched the last remaining canoe to be portaged over to White Bear Island. Charbonneau and Sacagawea accompanied this last canoe and the remaining baggage along with Captain Clark and York. It was the next day, while on this last portage, that Charbonneau, Sacagawea, and Clark almost lost their lives; while taking shelter in a ravine, the trio was nearly washed into the Missouri River by a torrent of water caused by a sudden rainstorm.

"Our Captains' Hide Lodge"
12" x 14" oil on board

"Cap. Clark myself the two Interpretters and the woman and child sleep in a tent of dressed skins. this tent is in the Indian stile, formed of a number of dressed Buffaloe skins sewed together with sinues. it is cut in such manner that when foalded double it forms the quarter of a circle, and is left open at one side where it may be attatched or loosened at pleasure by strings which are sewed to its sides to the purpose. to erect this tent, a parsel of ten or twelve poles are provided, fore or five of which are attatched together at one end, they are then elevated and their lower extremities are spread in a circular manner to a width proportionate to the demention of the lodge, in the same position orther poles are leant against those, and the leather is then thrown over them forming a conic figure."

— CAPTAIN MERIWETHER LEWIS, APRIL 7, 1805

This tipi, or "leather lodge" as the Captains would later call it, served its five residents well until May 15, 1806; while returning east through Nez Perce territory, Lewis mentioned in his journal that their *"leather lodge has become rotten and unfit for use."*

"Buffalo at Tower Rock"
10" x 28" oil on board

"this rock I called the tower. it may be ascended with some difficulty nearly to it's summit, and from it there is a most pleasing view of the country we are now about to leave. from it I saw this evening immence herds of buffaloe in the plains below."
— CAPTAIN MERIWETHER LEWIS, JULY 16, 1805

The formation Captain Lewis called *"the tower"* appears in the distance in this painting. Just as they did for the Indians, the bison had sustained the Corps for most of the past year. Private Joseph Field had killed the first one in August of 1804. These immense herds of bison would be the last that the Corps would see until the next summer on their return trip.

"Evening near Tower Rock"
9" x 20" oil on board

"Low Light at the Three Forks—July 28, 1805"
36" x 48" oil on canvas

"beleiving this to be an essential point in the geography of this western part of the Continent I determined to remain at all events untill I obtained the necessary data for fixing it's latitude Longitude &c."
— CAPTAIN MERIWETHER LEWIS, JULY 27, 1805

The river had been a strong opponent for several days, and the men were in a *"continual state of utmost exhaustion."* By mid-morning the Corps entered a vast valley occupied by the Three Forks of the Missouri River. Captain Clark and a few men who had been recon-noitering ahead of the canoes returned to camp equally as sick and exhausted. A halt was called for two days of rest; the time was used for hunting and preparing skins while Captain Lewis obtained his readings of longitude and latitude.

"Sunrise over Beaver's Head—August 8, 1805"

32" x 38" oil on canvas

"the Indian woman recognized the point of a high plain to our right which she informed us was not very distant from the summer retreat of her nation on a river beyond the mountains which runs to the west. this hill she says her nation calls the beaver's head from a conceived resemblance of it's figure to the head of that animal."

— CAPTAIN MERIWETHER LEWIS, AUGUST 8, 1805

The Corps of Discovery was in a sorry state as they fought their way up the narrow and crooked Jefferson River, today called the Beaverhead River. Many of the men were ailing from the rigors of each day's progress. When Sacagawea recognized this rock formation and pronounced that her Shoshone people were close, it gave a needed boost to morale. Viewed from other directions, the rock formation does not resemble a beaver's head. However, in the first hours after sunrise, when viewed from the south and west, the complex mass of rock indeed appears as the head of a swimming beaver.

"Sunset on Lemhi Pass—August 12, 1805"
6" x 12" oil on board

"the mountains are high on either hand…here I halted a few minutes and rested myself. two miles below McNeal had exultingly stood with a foot on each side of this little rivulet and thanked his god that he had lived to bestride the mighty & heretofore deemed endless Missouri. after refreshing ourselves we proceeded on to the top of the dividing ridge from which I discovered immence ranges of high mountains still to the West of us with their tops partially covered with snow."

— CAPTAIN MERIWETHER LEWIS, AUGUST 12, 1805

Captain Lewis and three members of the Corps were traveling ahead of Captain Clark and the canoes. On August 12, in their continuing effort to locate the Shoshone, the small group followed the ever-shrinking Jefferson River (today known as the Beaverhead River) to its source in the ravines under Lemhi Pass. After going over the pass, they camped just out of sight in a ravine, shown in the lower portion of this painting, where they found wood for a fire.

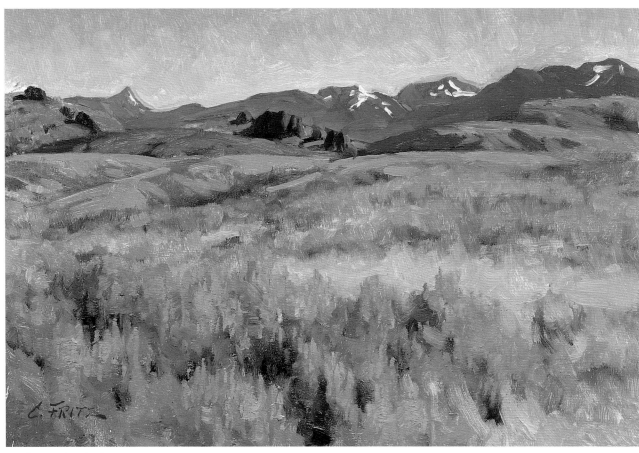

"Study near the Shoshone Camp"
8" x 12" oil on board

"We set out very early on the Indian road which still led us through an open broken country in a westerly direction. a deep valley appeared to our left at the base of a high range of mountains…their tops were also partially covered with snow."
— CAPTAIN MERIWETHER LEWIS, AUGUST 13, 1805

DETAIL:
"Captain Lewis Meeting the Shoshones"

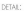

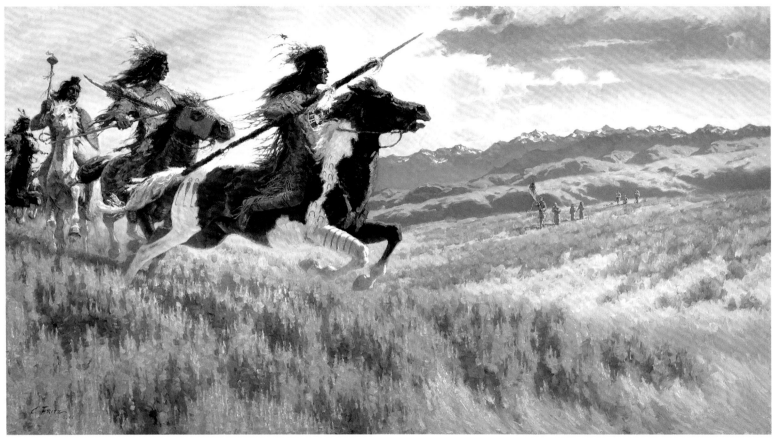

"Captain Lewis Meeting the Shoshones"
36" x 66" oil on canvas

"we had marched about 2 miles when we met a party of about 60 warriors mounted on excellent horses who came in nearly full speed, when they arrived I advanced towards them with the flag leaving my gun with the party about 50 paces behi[n]d me."

— CAPTAIN MERIWETHER LEWIS, AUGUST 13, 1805

With this simple journal entry, a modest Captain Lewis describes one of his most har-rowing moments of the whole expedition. After camping at Lemhi Pass overnight, the Captain and his party had continued to travel down toward today's Snake River. An elderly Shoshone woman and a twelve-year-old girl whose confidence Lewis had just gained were leading him to their camp. As they neared the camp, the Shoshone warriors surprised them in a ravine and came on at full charge. The attack was in response to an earlier report that an enemy was close by. Lewis's act of disarming and moving forward, offering only the flag for defense, exemplifies his now mature confidence in the Corps of Discovery's mission and his ability to fearlessly carry out that mission.

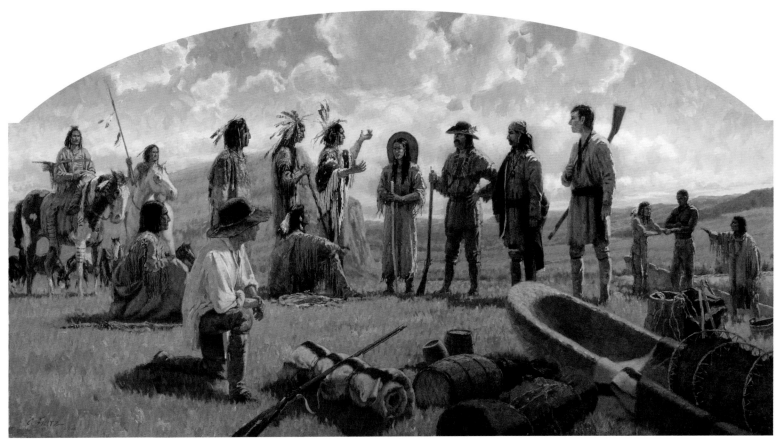

"Camp Fortunate, 'Where we laid up our canoes and commenced our voyage by land' "
36" x 66" oil on canvas

DETAIL:
"Camp Fortunate, 'Where we laid up our canoes and commenced our voyage by land' "

"We now formed our camp just below the junction of the forks on the Lard. side in a level smooth bottom covered with a fine terf of green sword. here we unloaded our canoes and arranged our baggage on shore; formed a canopy of one of our large sails and planted some willow brush in the ground to form a shade for the Indians to set under while we spoke to them…and through the medium of Labuish, Charbono and Sah-cah-gar-weah, we communicated to them fully…"

"The sperits of the men were now much elated as the prospect of geting horses."

"the forks of this river is the most distant point to which the waters of the Missouri are navigable. of course we laid up our canoes at this place and commenced our voyage by land."

<div align="right">— CAPTAIN MERIWETHER LEWIS, AUGUST 17, 1805</div>

"our officers Captains Lewis & Clark told the head chief of them that they wanted to by [buy] their horses to take our baggage over the Mountains. the Chief Said they would let us have the use of their horses & promised to assist us over as much as lay in their power."

<div align="right">— SERGEANT JOHN ORDWAY, AUGUST 17, 1805</div>

For more than two months, the Captains and their men had been frustrated travelers in a foreign land. In June they had toiled for days over the Great Falls portage and, upon reaching the other side, spent July and part of August on rivers that had turned south, taking them not into the mountains but on a course parallel to the mountains. The endless blue ridge to the west taunted them daily with its apparent proximity, but they were getting no closer.

During the past winter, the Captains had learned from the Mandans and Charbonneau that the help of the Shoshone, whom they referred to as the *"horse Indians,"* would be necessary for the Expedition's success in crossing over the mountains and the Continental Divide. Now that the Shoshone had been located, Captain Lewis needed to convince them to supply the Expedition with horses. Lewis tells us in the Journals of the complex chain of interpreters he used to communicate with the Shoshone. He spoke in English to Labiche, who spoke French to Charbonneau, who spoke Hidatsa to Sacagawea, who then spoke Shoshone to Chief Cameahwait, her brother.

With Cameahwait's promise of help, the men, who were completely exhausted from dragging the canoes up the shallow river, experienced a joyous renewal of hope, and their spirits soared.

Lewis named this site Camp Fortunate—which is located near today's Dillon, Montana. The name serves as a testament to the relief the Corps felt upon reaching the Shoshone.

"I had now nine horses and a mule, and two which I had hired made twelve these I had loaded and the Indian women took the ballance of the baggage. I had given the Interpreter some articles with which to purchase a horse for the woman which he had obtained."

— CAPTAIN MERIWETHER LEWIS, AUGUST 24, 1805

Sacagawea was a Lemhi Shoshone. A marauding band of Hidatsas kidnapped her when she was about eleven years old and took her east to their earthlodge villages along the Knife River, in today's North Dakota. It was here that Sacagawea met Lewis and Clark in the winter of 1804–1805.

Contrary to legend, Sacagawea did not "guide" Lewis and Clark. Her husband, Charbonneau, had initially convinced the Captains of her value to the Expedition as a translator to negotiate with the Shoshone for horses. It is notable that after serving this purpose, Sacagawea and Charbonneau did not remain with the Shoshone, nor did they return to the Knife River villages. Instead, they continued on with the Captains to the Pacific, firm evidence of their broader value to the Expedition.

When Sacagawea and the Corps reached the Shoshone, it quickly became clear that this was the band from which she had been taken. After six or seven years apart, she experienced an emotional reunion with a childhood friend and also her brother, Cameahwait, who had become chief.

In this painting she is depicted during her departure from Camp Fortunate, going west up today's Horse Prairie Creek, in southwestern Montana. The next day, with the help of the Shoshone women and their horses, the Expedition crossed over Lemhi Pass and the Continental Divide, putting the Corps at the Snake River, which flowed to the Pacific Ocean.

Through Sacagawea's chance encounter with President Thomas Jefferson's Corps of Discovery on the wintry plains of today's North Dakota, she confirmed her place in American history. Of all the members of the Corps, it is Sacagawea whose image was engraved on an American coin 200 years later.

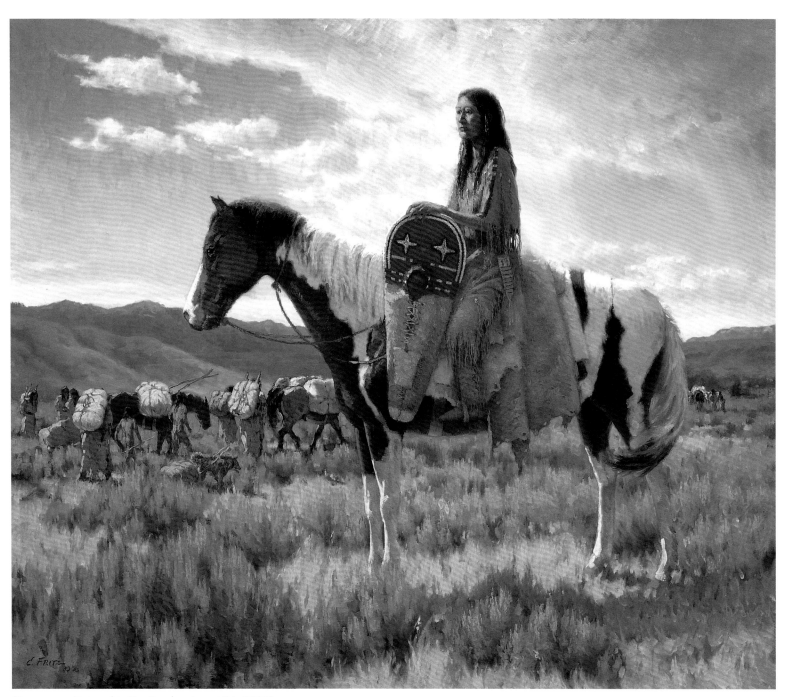

"Sacagawea Returned to Her People—August 24, 1805"

32" x 38" oil on canvas

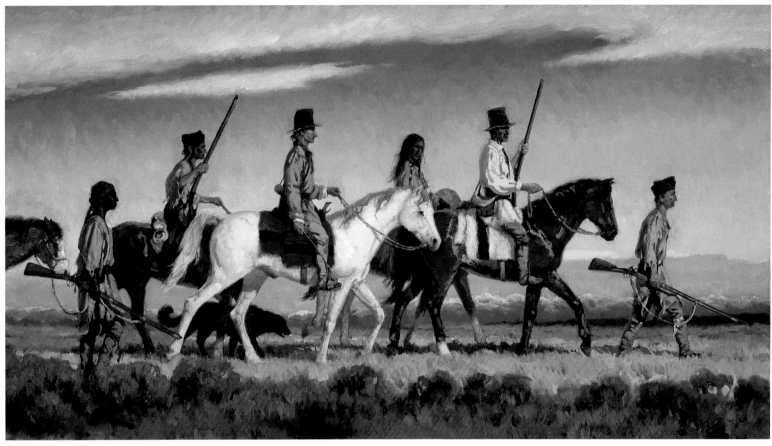

"We Proceeded On"
20" x 36" oil on canvas

"The morning being fair and pleasant and wind favourable we set sale at an early hour, and proceeded on very well…"
— CAPTAIN MERIWETHER LEWIS, MAY 6, 1805

"a fine morning Set out early and proceeded on…"
— CAPTAIN WILLIAM CLARK, SEPTEMBER 1, 1805

"a Cloudy morning Set out early and proceeded on through an open vallie for 23 miles…"
— CAPTAIN WILLIAM CLARK, SEPTEMBER 8, 1805

Throughout the Journals, the phrase *"proceeded on"* is frequently used. Within those words, the dogged determination exhibited by the Corps of Discovery is communicated. The Captains use this phrase regularly, sometimes daily, and with it, their composed determination is articulated in wonderful simplicity.

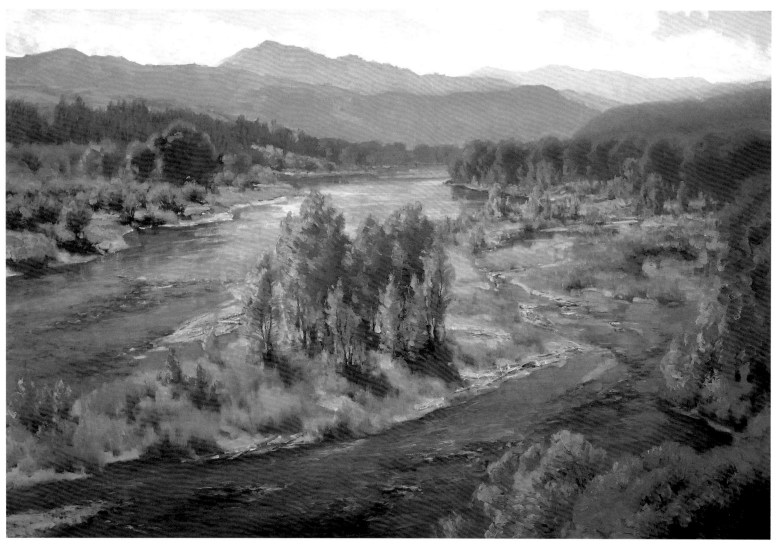

"Clark's River near Travelers' Rest—September 10, 1805"

36" x 54" oil on canvas

"a clear pleasant morning. not So cold as usal. as our road leads over a mountain to our left,...our Captains conclude to Stay here this day to take observations, and for the hunters to kill meat to last us across the mountain and for our horses to rest &c."

— SERGEANT JOSEPH WHITEHOUSE, SEPTEMBER 10, 1805

After the grueling days of crossing Lemhi Pass and finding no route to travel on the Snake River, the Corps traveled north up the valley of today's Bitterroot River. Enduring harsh weather conditions, the Corps needed a day to rest. A halt was called on September 10, and the day was used to prepare for the anticipated hardships of crossing *"those unknown formidable snow clad Mountains."* Hunters were sent out and all others were employed with preparing equipment and clothing for the march ahead. On September 9, Lewis wrote of the predominance of cottonwood trees near the river. He noted that these were *"the narrow leafed"* kind, which is the variety of cottonwood found at higher elevations.

"Trapping Beaver, Travelers' Rest Creek"
10" x 12" oil on board

"there was a remarkable large beaver caught by one of the party last night. these anamals are now very abundant. I have met with several trees which have been felled by them 20 Inches in diameter."

— CAPTAIN MERIWETHER LEWIS, APRIL 16, 1805

Throughout the Journals, references are made to the abundance of beaver. The pelts of North America's largest rodent have long been used to create felt; historians trace the use of felt made from beaver pelts to the early Roman and Russian empires. In Europe in the fifteenth century, gentlemen began wearing fashionable hats made of the material.

Demand for beaver pelts grew well into the 1800s, drastically reducing beaver populations across northern Europe and Russia. To solve their supply problem, European entrepreneurs looked to the opening of the New World as the next source for beaver pelts. While England and France vied for the fur trade in Canada, President Thomas Jefferson looked to gain a monopoly on the fur trade in the newly acquired Louisiana Territory.

"Crossing the Most Terrible Mountains We Ever Beheld"
58" x 36" oil on canvas

"I…halted for the rear to come up and to let our horses rest…about 2 hours the rear of the party came up much fatigued & horses more So, Several horses Sliped and roled down Steep hills which hurt them verry much."
— CAPTAIN WILLIAM CLARK, SEPTEMBER 15, 1805

"Last night about 12 o'clock it began to snow. We renewed our march early, though the morning was very disagreeable, and proceeded over the most terrible mountains I ever beheld. It continued snowing until 3 o'clock P. M. when we halted, took some more soup, and went on till…we encamped for the night."
— SERGEANT PATRICK GASS, SEPTEMBER 16, 1805

Leaving Travelers' Rest, the Corps struck out on September 11 to cross "those formidable mountains." The conditions deteriorated with each passing day, and on September 14 Captain Clark wrote, "The Mountains which we passed to day much worst than yesterday the last excessively bad & Thickly Strowed with falling timber & Pine Spruc fur Hackmatak & Tamerack, Steep & Stoney our men and horses much fatigued…."

Adding to their trials, on September 14 their Shoshone guide, Toby, lost the trail and they descended down into the steep and tangled drainage of the Lochsa River in today's Idaho. As depicted in this painting, a massive amount of energy was expended the next day as they climbed back up the steep ridges to regain the Nez Perce Trail. As they fought to return to the trail on September 15, Captain Clark lost his portable writing desk. He wrote, "the party came up much fatigued & horses more So, Several horses Sliped and roled down Steep hills which hurt them verry much The one which Carried my desk & Small trunk Turned over & roled down a mountain for 40 yards & lodged against a tree, broke the Desk the horse escaped and appeared but little hurt Some others verry much hurt…."

"Struggling over the Nez Perce Trail"
24" x 16" oil on canvas

"began to Snow about 3 hours before Day and Continud. all day the Snow in The morning 4 Inches deep on The old Snow, and by night we found it from 6 to 8 Inches deep…(on) The South…Steep hills Side & falling timber Continue to day, and a thickly timbered Countrey of 8 different kinds of pine, which are So covered with Snow, that in passing thro them we are continually covered with Snow, I have been wet and as cold in every part as I ever was in my life, indeed I was at one time fearfull my feet would freeze in the thin mockersons which I wore…to describe the road of this day would be a repitition of yesterday excpt the Snow which made it much wors to proseed…"

— CAPTAIN WILLIAM CLARK, SEPTEMBER 16, 1805

Exhausted, cold, and without food, their suffering didn't end until September 20, when they were able to descend to lower elevations, where the temperatures were not as frigid. On the return trip from the Pacific the following year, the memory of their trials in these mountains was still raw in the mind of Captain Lewis. On June 2, 1806, he wrote, *"we are obliged to have recourse to every subterfuge in order to prepare in the most ample manner in our power to meet that wretched portion of our journy, the Rocky Mountain, where hungar and cold in their most rigorous forms assail the waried traveller; not any of us have yet forgotten our sufferings in those mountains in September last, and I think it probable we never shall."*

"Dusk on the Kooskooskee River"
10" x 7.5" oil on canvas mounted on board

The Kooskooskee, today's Clearwater River, flows west until its confluence with the Snake River and eventually the Columbia River. This river provided the Nez Perce with a stable food source that contributed greatly to their wealth and well-being. The annual salmon runs were not only a reliable source of nutrition but they also were crucial to the Nez Perce world view, just as the bison were to the Plains Indians. The Nez Perce were in a healthy condition that October day when the weakened Corps of Discovery came out of the mountains and found the Nez Perce camped at Weippe Prairie. The river and its bounty helped make it possible for the Nez Perce to be so generous and helpful to the Expedition.

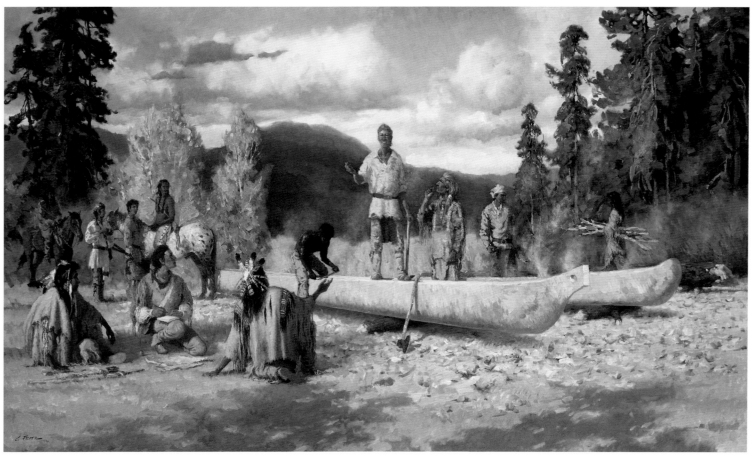

"Crafting Canoes to Ply the Columbia"
36" x 62" oil on canvas

"a fair morning the party divided into five differeent parties and went at falling five pitch pine trees for 5 canoes, all near our Encampment…all the party that were able to work went at makeing the canoes and oars. the natives visit us and catch Some fresh Sammon which we purchase from them…"
— SERGEANT JOHN ORDWAY, SEPTEMBER 27 AND 28, 1805

"…the most friendly, hones and ingenuous people that we have seen in the course of our voyage and travels."
— SERGEANT PATRICK GASS, JULY 4, 1806

The men of the Expedition, exhausted from their trek over the Bitterroot Mountains, initially suffered greatly from their new diet of camas roots and salmon brought to them by the Nez Perce. Eventually they began to recover, and all that were able were employed in crafting canoes from the large ponderosa pines that lined the hillsides of today's Clearwater River. Relations were good between the Nez Perce Indians and the Corps of Discovery, a legacy of cooperation that lasted until the treaty abuses of the 1870s.

Patrick Gass recorded in his journal on October 1, 1806, *"To save [the men] from hard labour, we have adopted the Indian method of burning out the canoes."* This technique had not been possible with the cottonwoods of the plains because they held too much water within their trunks; the pines held pitch.

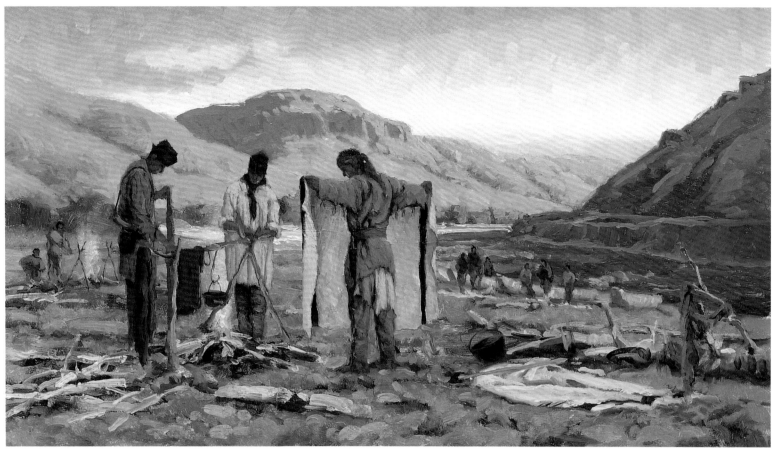

"Drying Baggage near Colter's Creek"
10" x 18" oil on board

"…passed 15 rapids…just below which one canoe which Serjt. Gass was Stearing was nearle turning over. She…Split open on one Side and Bottom filled with water & Sunk…the men, Several of which Could not Swim hung on to the Canoe…our Small Canoe and one Indian Canoe…toed the empty Canoe on Shore…"
— CAPTAIN WILLIAM CLARK, OCTOBER 8, 1805

The Corps camped for the evening just below Colter's Creek, today's Potlatch Creek, drying out the wet baggage and repairing the split canoe. Sergeant Gass recorded that at this place there were Indian lodges on both sides of the Clearwater River, and Captain Clark commented in his journal that *"those people appeared disposed to give us every assistance in their power dureing our distress—"*

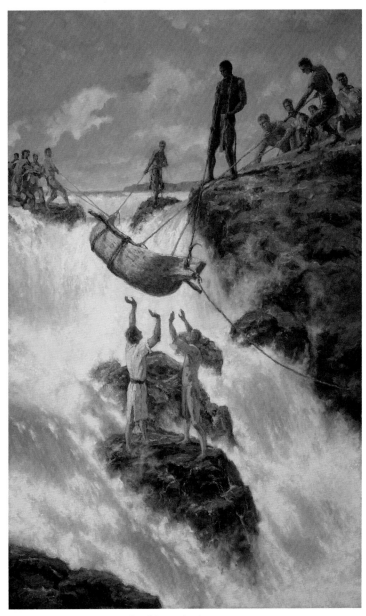

"Descending the Grand Falls of the Columbia"
36" x 22" oil on canvas

"Took the Canoes over the Portage on the Lard. Side with much dificuelty…I then decended through a narrow chanel of about 150 yards wide…in which the chanel is divided by 2 large rocks at this place we were obliged to let the Canoes down by Strong ropes of Elk Skin which we had for the purpose…"

— CAPTAIN WILLIAM CLARK, OCTOBER 23, 1805

"The Latitude at this place which is called the grand falls of the Columbia River as taken by Capt. Lewis is 45°…North. The hight of the particular falls in all is 37 feet eight Inches, and…the water divided in several channels by the rocks."

— SERGEANT JOHN ORDWAY, OCTOBER 23, 1805

Ever since pushing off in their canoes at the Nez Perce villages, the Corps made rapid progress, benefiting daily from the river's rapid drop and its anxious race to the Pacific. Now, on October 23, the Corps stood at the top of the thundering Grand Falls of the Columbia River, today known as Celilo Falls. Beyond this wall of water was a series of frightful descents through more roaring waterfalls, wild rapids, and rushing chutes. It would be twelve days of continuous peril for the Corps as they negotiated a route down the foaming river.

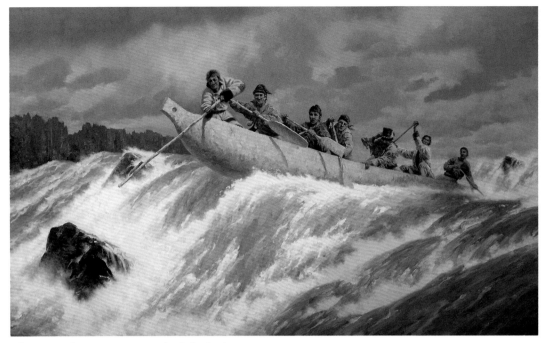

"The Corps of Discovery Running the Columbia"
36" x 60" oil on canvas

"…a rock…Confined the river in a narrow channel of about 45 yards this continued for about ¼ of a mile & widened to about 200 yards, in those narrows the water was agitated in a most Shocking manner boils Swell & whorl pools, we passed with great risque It being impossible to make a portage of the Canoes…"

"The whole of the Current of this great river must at all Stages pass thro' this narrow chanel…narrow and compressed for about 2 miles…" — CAPTAIN WILLIAM CLARK, OCTOBER 24, 1805

"This Great Shute or falls is about ½ a mile with the water of this great river Compressed within the Space of 150 paces in which there is great numbers of both large and Small rocks, water passing with great velocity forming & boiling in a most horriable manner…"

— CAPTAIN WILLIAM CLARK, OCTOBER 31, 1805

It's 2,000 miles from St. Louis to the Continental Divide, and from the Divide to the Pacific Ocean it's only 1,000 miles. In order for the Columbia River to reach sea level in only half the distance, Lewis and Clark reasoned that there would have to be many large rapids and waterfalls. They were right.

In October 1805 the Captains wrote a great deal about the rapids, rocks, and fast water of this portion of the river. A long stretch of particularly threatening water began below Celilo Falls and had to be navigated. It included *"the Short and Long Narrows," "the Great Shute,"* and *"the Cascades."* Taken together they amounted to a continuous stretch of narrow spots and rapids into which the entire Columbia River's volume was forced. In some places the Corps portaged, and in others they ran the rapids in their clumsy canoes. Expecting to capitalize on the Corps's misfortune, the natives would wait at the bottom of the rapids, hoping to pluck out treasures as the group floated by. But all of the canoes and all of the men survived the various cascades of the Columbia River without incident.

"The Wishram Land at Sunrise"
10" x 15" oil on board

"Saw a mountain bearing S. W. Conocal form Covered with Snow."
— CAPTAIN WILLIAM CLARK, OCTOBER 18, 1805

"The face of the Countrey, on both Side of the river above and about the falls, is Steep ruged and rockey open and contain but a Small preportion of erbage, no timber a fiew bushes excepted…"
— CAPTAIN WILLIAM CLARK, OCTOBER 25, 1805

The Journals refer to the Indians living on the north side of Celilo Falls as the Echeloots; they are correctly called the Wishrams. Celilo Falls, *"the Narrows,"* and numerous other vantage points along the Columbia River created highly productive sites for harvesting migrating salmon. Much like the Mandans of the Upper Missouri, the Wishram Indians leveraged this great food resource, and their villages became huge marts of trade where salmon served as the means of barter.

As the Expedition moved through this area, they began to see the volcanic peaks that had been previously documented by traders sailing near the mouth of the Columbia, and amongst the Indians they began to notice trade goods and European clothing.

"Sunset near Fort Rock Camp"
16" x 32" oil on canvas

"...Came to at a high point of rocks below the mouth of a Creek which falls in on the Lard Side and head up towards the high Snow mountain to the S W...we took possession of a high Point of rocks to defend our Selves in Case the threts of those Indians below Should be put in execution against us."
— CAPTAIN WILLIAM CLARK, OCTOBER 25, 1805

The Corps of Discovery spent three days camped at Fort Rock Camp, the present site of The Dalles, Oregon. Rumors of hostilities from tribes farther down the Columbia River kept the men at the ready. They were vulnerable now: during portages their baggage and canoes would often be separated and needed to be tended to at all times, and at the same time the many falls required their complete attention and courage. The rumored hostilities never materialized, and the Corps pushed on.

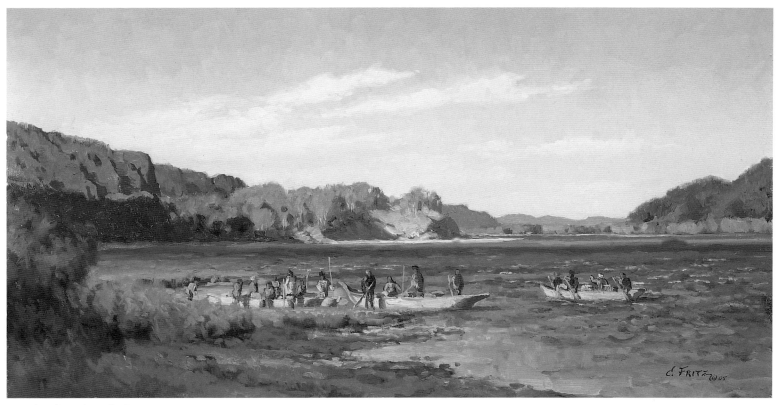

"Headwinds on the Columbia"
10" x 20" oil on board

"Wind hard from the west all the last night and this morning."

— CAPTAIN WILLIAM CLARK, OCTOBER 27, 1805

"…the wind rose and we were obliged to lie by all day…"

— CAPTAIN WILLIAM CLARK, OCTOBER 28, 1805

"…wind blew hard accompanied with rain all the evening, our Situation not a verry good one for an encampment, but Such as it is we are obliged to put up with, the harbor is a Safe one, we encamped on the Sand wet and disagreeable"

— CAPTAIN WILLIAM CLARK, OCTOBER 28, 1805

Though sometimes more candid in the Journals, Clark stoically endured miserable conditions and set an example of hardiness that the men followed implicitly. At this stage, the Captains and the men were eager to reach the Pacific. During their time on the Columbia, it seemed that the Corps regularly risked their lives to accomplish the goal quicker. Having spotted what they first thought were sea otters and later determined were seals, the Corps now keenly anticipated journey's end.

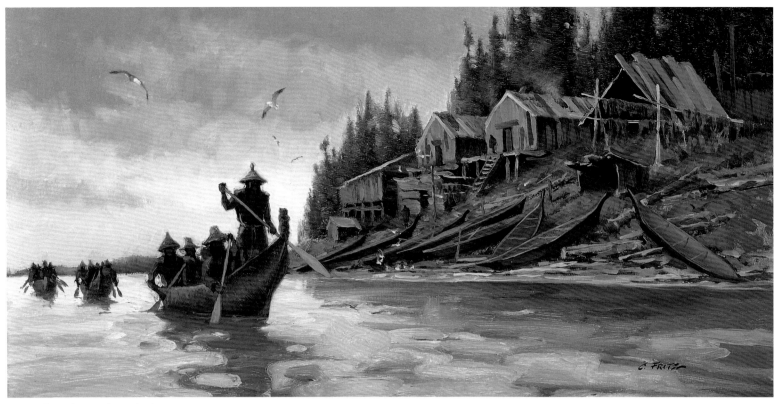

"Chinook Traders on the Columbia"
10" x 20" oil on board

"We met 4 Canoes of Indians from below, in which there is 26 Indians, one of those Canoes is large, and ornimented with Images on the bow & Stern. That in the Bow the likeness of a Bear, and in Stern the picture of a man—" — CAPTAIN WILLIAM CLARK, NOVEMBER 5, 1805

Below the rapids, the lower Columbia became more placid, and the canoes floated easily. The men began to observe tidal effects, the river widened, and they were able to make rapid progress toward the Pacific.

The Chinook people inhabited this portion of the Columbia; the Corps encountered them daily and documented their interactions in the Journals. The Chinooks possessed many items of European origin, which they acquired by trading sea otter pelts to merchant ships that visited the Columbia estuary. Captain George Vancouver, representing Great Britain, first dropped anchor here in 1792, initiating thirteen years of trade with the Indians before Lewis and Clark arrived.

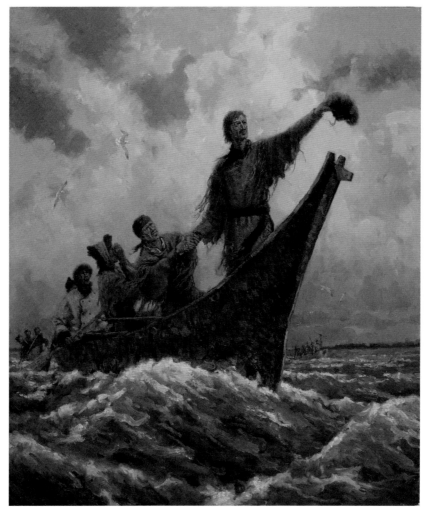

"Ocean in view O! the joy"
28" x 24" oil on canvas

"Great joy in camp we are in View of the Ocian, this great Pacific Octean which we been So long anxious to See. and the roreing or noise made by the waves brakeing on the rockey Shores (as I Suppose) may be heard distictly"
— CAPTAIN WILLIAM CLARK, NOVEMBER 7, 1805

On the afternoon of November 7, 1805, after nineteen months of endless trials, the rain and fog lifted to reveal the Columbia River estuary near the Pacific Ocean. In May of 1792, an American ship captain named Robert Gray had anchored at the mouth of the Columbia River and charted this location. For the first time since their stay at the Mandan villages, the Corps was no longer in uncharted country. Despite the isolation they had often experienced, the men felt the exhilaration of knowing that they had crossed the unknown frontier, and with each dip of their paddle into the brackish water, they were moving back onto the world's map. They had accomplished their goal of crossing the continent by land.

Nine days later, Clark recorded his calculation that the Pacific Ocean lay 4,142 river (and mountain) miles from the mouth of the Missouri River.

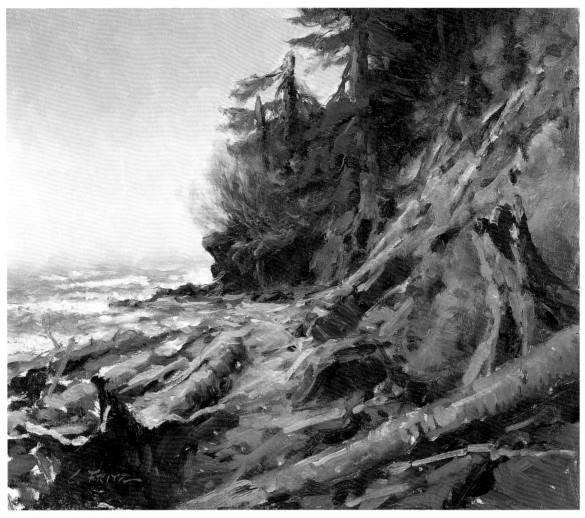

"Shoreline at the Pacific"
10" x 12" oil on board

"Ocean in view O! the joy"

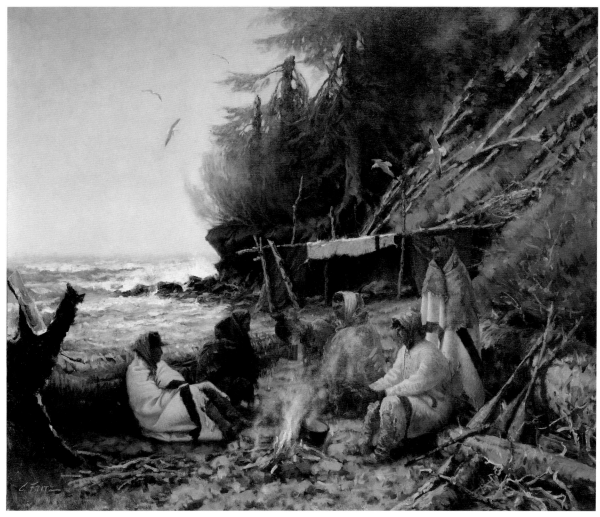

"Our Terrible Condition at the Pacific"
25" x 30" oil on canvas

"…the wind verry high from the S.W. with most tremendious waves braking with great violence against the Shores, rain falling in torrents, we are all wet as usial and our Situation is truly a disagreeable one; the great quantities of rain which has loosened the Stones on the hill Sides and the Small Stones fall down upon us, our canoes at one place at the mercy of the waves, our baggage in another and our Selves and party Scattered on floating lags and Such dry Spots as can be found on the hill Sides, and Crivices of the rocks."
— CAPTAIN WILLIAM CLARK, NOVEMBER 11, 1805

Perhaps, more than portaging the Great Falls or crossing the Bitterroots, this episode proved the most brutal test of endurance. For days, storms off the Pacific made progress or regress impossible. On the north side of the Columbia River estuary, the members of the Corps found themselves pinned between angry Pacific storms, rising tides, and steep, inhospitable land. To save their canoes from the pounding surf, they temporarily sank them and sent out a scouting party to find a better campsite.

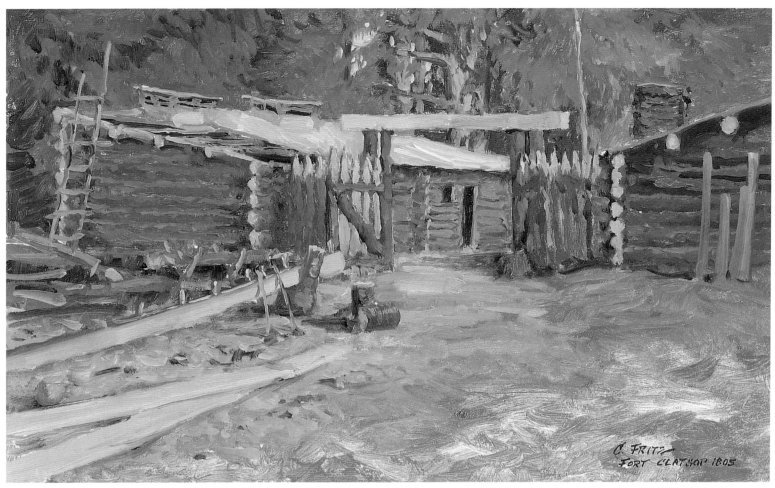

"Fort Clatsop—December 1805"

10" x 16.75" oil on board

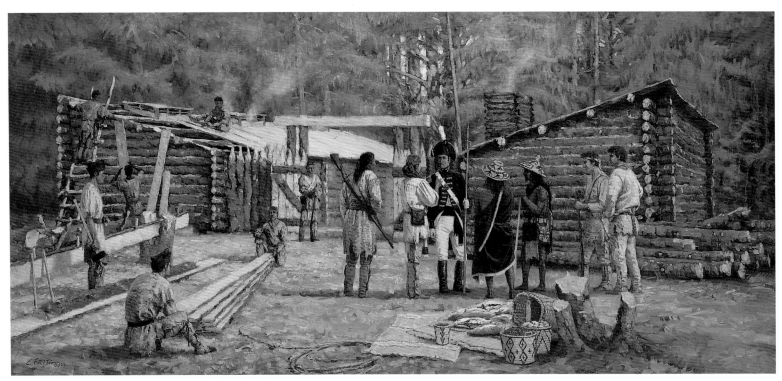

"Construction and Diplomacy at Fort Clatsop"
25" x 54" oil on canvas

"rained and blew hard last night Some hard Thunder, The rain continued as usial all day…we dry our wet articles and have the blankets fleed, The flees are So troublesom that I have Slept but little for 2 nights past…hut Smoke verry bad." — CAPTAIN WILLIAM CLARK, DECEMBER 26, 1805

While the Corps was pinned down on the north side of the Columbia River, a vote was taken. It was decided by the majority to cross over to the south side of the Columbia where the Clatsop Indians had told them game was more plentiful. Included in the vote were Captain Clark's slave York and Sacagawea. Held in the far reaches of the American wilderness, this vote was an amazing moment of democracy far ahead of its time. The Fifteenth and Nineteenth Amendments to the U.S. Constitution, granting freed slaves and women the right to vote, respectively, were still many decades away.

Fort Clatsop, near today's Astoria, Oregon, was built to serve as winter quarters. Although the miserable winter at Fort Clatsop seemed to drag on forever, the dreary season did include frequent visits from the Chinook and Clatsop nations.

"Keeping the Journals, Fort Clatsop"
10" x 15" oil on canvas

The Journals of Lewis and Clark are among the most valuable treasures in our nation's archives. Consider the daily enterprise required to meticulously record and document such a strenuous journey. Despite primitive instruments and difficult conditions, the Captains and several of their men persevered to provide us with comprehensive descriptions of cultures, plants, animals, climate, river conditions, distance, and geography. More than 200 years later, we are still enchanted by these texts.

The misspellings and inconsistent spellings of the same word in the Journals are often humorously noted by historians. In the 1800s, the standardization of spelling that we are familiar with today did not exist; the men were actually spelling in accordance with the standards of the time. Andrew Jackson, president from 1829 to 1837, once said, "It's a damn poor mind that can only think of one way to spell a word"—which makes Captain Clark a man with a fine mind indeed, having spelled the word Sioux twenty-eight different ways!

Illiteracy was common in 1804, and not all members of the Expedition were capable of keeping their own journal. Army sergeants, however, were required to be literate; the Captains ordered their three to keep daily logs. Those journals known to us come from Captains Lewis and Clark, Sergeants Gass, Floyd, and Ordway (the only writer who never missed a single day's entry), and Private Joseph Whitehouse.

"Study at Point of Clark's View"

10" x 12" oil on board

"The Pacific from Point of Clark's View—January 8, 1806"
36" x 48" oil on canvas

"The last night proved fair and Cold wind hard from the S. E. we Set out early and proceeded to the top of the mountain next to the which is much the highest part and that part faceing the Sea is open, from this point I beheld the grandest and most pleasing prospects which my eyes ever surveyed, in my frount a boundless Ocean; to the N. and N. E. the coast as far as my sight Could be extended, the Seas rageing with emence wave and brakeing with great force from the rocks of Cape Disapointment as far as I could See to the N. W. The Clatsops Chinnooks and other villagers on each Side of the Columbia river and in the Praries below me, the meanderings of 3 handsom Streams heading in Small lakes at the foot of the high Country; The Columbia River for a long Some distance up, with its Bays and Small rivers and on the other Side I have a view of the Coast for an emence distance to the S. E. by S. the nitches and points of high land which forms this Corse for a long ways aded to the inoumerable rocks of emence Sise out at a great distance from the Shore and against which the Seas brak with great force gives this Coast a most romantic appearance. from this point of View my guide pointed to a village at the mouth of a Small river near which place he Said the whale was…"

— CAPTAIN WILLIAM CLARK, JANUARY 8, 1806

"Fort Mountain on the Two Medicine River—July 7, 1806"
8" x 12" oil on board

On March 23, 1806, the Corps of Discovery left Fort Clatsop and began their journey home, arriving back at Travelers' Rest on June 30, 1806. Here Lewis and Clark parted company. Captain Clark headed to the Yellowstone Basin, with plans to reunite with Lewis at the confluence of the Missouri and the Yellowstone rivers in early August. Captain Lewis and his party departed from Travelers' Rest and proceeded northeasterly through the Dearborn River country and eventually to the Two Medicine River. They then descended it to the east, going past *"Fort Mountain,"* eventually returning to the Missouri River at today's Great Falls, Montana. They had named the butte the previous summer while traveling west. Today Fort Mountain is called Square Butte and was made famous in many of Charles M. Russell's paintings.

After reaching the Great Falls, Captain Lewis and three men traveled to the northern extremity of today's Cut Bank Creek (just east of today's Glacier National Park) in the hopes of taking a sextant reading at that location. Cloudy weather had frustrated their attempts, and they were forced to leave what they called Camp Disappointment. Traveling southeast to return to the Missouri River, they encountered eight young Blackfeet Indians. The Blackfeet were feared because they had developed a strong relationship with Canadian traders who were supplying them with guns; Lewis indicated in the Journals his desire to avoid any encounters with them.

After conversing with the young Blackfeet men that evening under a wickiup made of willows and hide, Captain Lewis exhibited an uncharacteristic level of complacency by deciding to camp with them overnight. He and his men took turns at guard duty through-out the night, but when Joseph Field was on duty in the morning he carelessly put his gun down, which allowed a Blackfeet to snatch it. Field cried out, waking the others, who grabbed their own guns. The Blackfeet took up guns as well, and in the ensuing confusion one Blackfeet man was stabbed and another was shot. The Expedition's goal to negotiate peacefully with this important tribe on the northern plains had failed, and two men were dead, the only Indians the Expedition killed.

"Violent Confusion: Captain Lewis's Encounter with the Blackfeet"
22" x 38" oil on canvas

"I now hollowed to the men and told them to fire on them if they attempted to drive off our horses, they accordingly pursued the main party who were drving the horses up the river and I pursued the man who had taken my gun who with another was driving off a part of the horses which were to the left of the camp, I pursued them so closely that they could not take twelve of their own horses but continued to drive one of mine with some others; at the distance of three hundred paces they entered one of those steep nitches in the bluff with the horses before them being nearly out of breath I could pursue no further, I called to them as I had done several times before that I would shoot them if they did not give me my horse and raised my gun, one of them jumped behind a rock and spoke to the other who turned around and stoped at the distance of 30 steps from me and I shot him through the belly…"

"we had caught and saddled the horses…when the Fieldses returned with four [more] of our horses… while the men were preparing the horses I put four sheilds and two bows and quivers of arrows which had been left on the fire…I also retook the flagg [that I had given them] but left the medal about the neck of the dead man that they might be informed who we were."

— CAPTAIN MERIWETHER LEWIS, JULY 27, 1806

"Fleeing the Blackfeet Revenge"
16" x 19" oil on canvas

"my design was to hasten to the entrance of Maria's river as quick as possible in the hope of meeting with the canoes and party at that place having no doubt but that they would pursue us with a large party and as there was a band near the broken mountains or probably between them and the mouth of that river we might expect them to receive inteligence from us and arrive at that place nearly as soon as we could, no time was therefore to be lost and we pushed our horses as hard as they would bear…after refreshing ourselves we again set out by moon light…heavy thunderclouds lowered arround us on every quarter but that from which the moon gave us light. we continued to pass immence herds of buffaloe all night as we had done in the latter part of the day. we traveled until 2 OCk in the morning having come by my estimate after dark about 20 ms."
— CAPTAIN MERIWETHER LEWIS, JULY 27, 1806

After the fight, the men immediately feared revenge and interception by Blackfeet hunting parties known to be in the area. Lewis and his companions picked the best of the remaining horses and rode hard for the Missouri. Riding almost nonstop for more than twenty-four hours, they covered more than 100 miles.

"Captain Clark Descending Elk River"
10" x 28" oil on board

"two of the horses was So lame owing to their feet being worn quit Smooth and to the quick, the hind feet was much the worst. I had Mockersons made of green Buffalow Skin and put on their feet which Seams to releve them very much in passing over the Stoney plains…The river and Creek bottoms abound in Cotton wood trees, tho' none of them Sufficently large for Canoes…no other alternetive for me but to proceed on down untill I can find a tree Sufficently large &c. to make a Canoe—."

— CAPTAIN WILLIAM CLARK, JULY 16, 1806

It was Captain Clark's party that would travel south and make a quick survey of the Yellowstone Basin during the return trip in the summer of 1806. The party set out from Travelers' Rest on July 3, traveling east through Montana's Big Hole country, past the Three Forks, and over what later would be called Bozeman's Pass. They met the Yellowstone at today's Livingston, Montana, continuing downstream on horseback past today's Crazy Mountains, looking for trees large enough to serve as canoes.

"The Rochejhone River near Canoe Camp—July 19, 1806"
10" x 18" oil on board

"I Encamped under a thick grove of [cottonwood] trees which was not Sufficiently large for my purpose, tho' two of them would mak small Canoes. I took Shields and proceeded on through a large timbered bottom imediately below in Serch of better trees for Canoes, found Several about the Same Size with those at my Camp."
— CAPTAIN WILLIAM CLARK, JULY 19, 1806

After traveling on horseback from the Nez Perce encampment in what is now Idaho, the explorers were understandably anxious to be off of their horses and back to traveling by water.

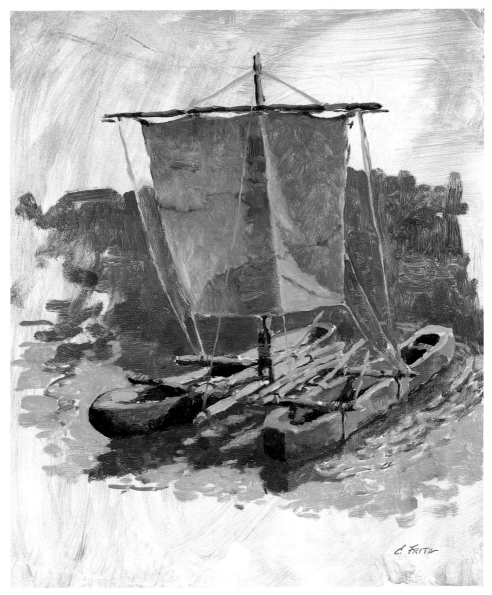

"Our Canoes on the River Rochejhone"
19" x 16" oil on board

*"I deturmined to have two Canoes made out of the largest of those trees and lash them together which will
Cause them to be Stu[r]dy and fully Sufficient to take my Small party & Self with what little baggage we
have down this river. had handles put in the 3 Axes and after Sharpening them with a file fell the two trees
which I intended for the two Canoes. those trees appeared tolerably Sound and will make Canoes of 28 feet
in length and about 16 or 18 inches deep and from 16 to 24 inches wide."*

— CAPTAIN WILLIAM CLARK, JULY 20, 1806

Near today's Park City, Montana, Clark and party found cottonwood trees of adequate
size for canoes. These two small dugouts carried the party down the Yellowstone River
through what is now eastern Montana.

"Absaroka Scouts, Elk River"
10" x 18" oil on board

"This morning I was informed that Half of our horses were absent."
<div align="right">— CAPTAIN WILLIAM CLARK, JULY 21, 1806</div>

"…they Serched for tracks all the evening without finding which Course the horses had taken, the plains being so remarkably hard and dry as to render It impossible to See a track of a horse passing through the hard parts of them. begin to Suspect that they are taken by the Indians and taken over the hard plains to prevent our following them…if they had Continued in the bottoms either up or down, their tracks Could be followed very well."
<div align="right">— CAPTAIN WILLIAM CLARK, JULY 22, 1806</div>

They call themselves Apsáalooke or Absaroka; the non-Indian traders understood the translation to mean the "Crow" tribe. They presided over the Yellowstone Basin and were noted for their horsemanship. Captain Clark never met, councited with, or even saw the Absarokas. Their presence was noted, however, as they successfully took half of Captain Clark's forty-nine horses on July 20, 1806. Clark composed a speech for the Absarokas, which he was never able to deliver. Among the other diplomatic messages he planned to tell them, he injected a wonderful bit of humor, something the affable Absarokas undoubt-edly would have enjoyed: *"I heard from some of your people [blank] nights past by my horses who complained to me of your people haveing taken 4 [24] of their cummerads."* (Clark, undated, after July 23, 1806.)

"Pompy's Tower—July 25, 1806"
30" x 36" oil on canvas

"…at 4 P M arived at a remarkable rock Situated in an extensive bottom on the Stard. Side of the river…this rock I ascended and from it's top had a most extensive view in every direction. This rock which I shall Call Pompy's Tower is 200 feet high and 400 paces in secumphrance and only axccessable on one Side…parts of it being a perpendicular Clift of lightish Coloured gritty rock…"
— CAPTAIN WILLIAM CLARK, JULY 25, 1806

The Apsáalooke (Crow, Absaroka) called this formation *Iishbiiammaache*, meaning "Where the Mountain Lion Lies," and used it as a lookout point. Most of the landmarks Lewis and Clark wrote about in the Journals were named and used by Native Americans long before the Corps's journey. Clark called this formation Pompy's Tower; "Pompy" was Clark's affectionate nickname for Jean Baptiste Charbonneau, son of Sacagawea and Toussaint Charbonneau.

"Wm. Clark—July 25, 1806"
15" x 10" oil on board

"The nativs have ingraved on the face of this rock the figures of animals…near which I marked my name and the day of the month & year."
— CAPTAIN WILLIAM CLARK, JULY 25, 1806

Since the 1800s, trappers, traders, cavalry troops, settlers, and steamboat passengers traveling the Yellowstone River have stopped at this landmark Clark named Pompy's Tower and looked for the famous captain's signature carved in the rock. Accepted today as the only tangible mark left by a member of the Corps of Discovery, Clark's signature is a treasure to students of the Expedition.

In 1882 the Northern Pacific Railroad made the first effort to protect the signature by placing an iron grate over it. In 1956 the Foote family, of Billings, Montana, came to own the land surrounding the site; they were generous stewards of the landmark for many years. Through the efforts of local citizens, the pillar passed to public ownership in 1991. In 2001 the site was designated Pompeys Pillar National Monument.

"Sunset over Pomp's Tower"
10" x 12" oil on board

"after Satisfying my Self Sufficiently in this delightfull prospect of the extensive Country around, and the emence herds of Buffalow, Elk and wolves in which it abounded, I decended and proceeded on a fiew miles, Saw a gang of about 40 Big horn animals…"

— CAPTAIN WILLIAM CLARK, JULY 25, 1806

It was perhaps at this time, as their journey together neared its end, that Clark began thinking about an offer he would soon make to the Charbonneau family to adopt their son, Jean Baptiste Charbonneau (Pompy), and educate him in St. Louis.

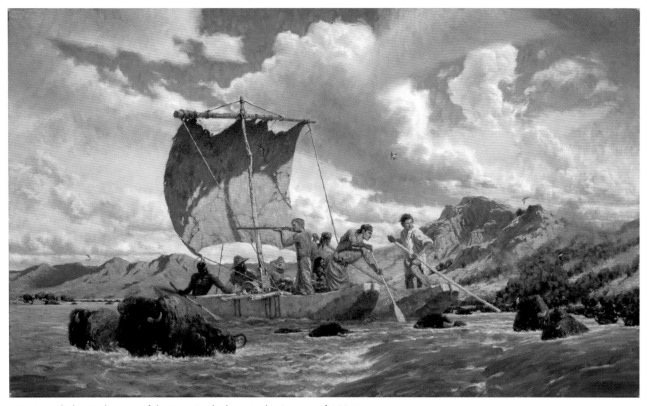

"Captain Clark's Exploration of the River Rochejhone in the Summer of 1806"

36" x 60" oil on canvas

"The Buffalow and Elk is estonishingly noumerous on the banks of the river on each Side…I Shot a very large fat buck elk from the Canoe near which I encamped…Shields killed a Deer & a antilope to day for the Skins which the party is in want of for Clothes."

— CAPTAIN WILLIAM CLARK, JULY 27, 1806

"…we were very near being detained by the Buffalow today which were Crossing the river we got through the line between 2 gangues."

— CAPTAIN WILLIAM CLARK, AUGUST 2, 1806

On July 24, Captain Clark wrote that *"for me to mention or give an estimate of the differant Spcies of wild animals on this river particularly Buffalow, Elk Antelopes & Wolves would be increditable. I shall there fore be silent on the Subject further."* Clark could not keep his word, however, finding himself overwhelmed by the astounding menagerie of species found in the Yellowstone River valley and writing at length about them. Floating through what is now eastern Montana, the Corps passed immense herds of bison and pronghorn in the rolling prairie, bighorn sheep in the cliffs, elk on every point, and wolves and grizzly bears roaming the riverbanks. The men collected specimens and hunted exuberantly, no doubt relishing the bounty after their lean winter on the coast.

The party was also eager to reach the Missouri confluence and their rendezvous with Captain Lewis. They were traveling fast down the Yellowstone with the aid of the current, a sail, and the prevailing west wind at their backs. To understand the Yellowstone River's remoteness in 1806, consider that it would be another fifty years before the United States sent another survey party up the river.

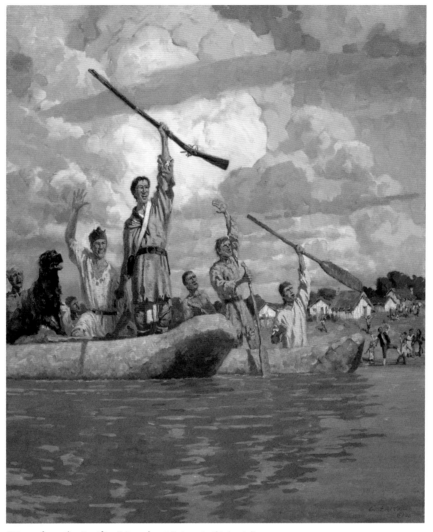

"Home from the Pacific: Triumphant Return to St. Louis"
30" x 25" oil on canvas

"...about 12 oClock we arrived in Site of St. Louis fired three Rounds as we approached the Town...the people gathred on the Shore and Huzzared three cheers...drew out the canoes then the party all considerable much rejoiced that we have the Expedition Completed...and then we entend to return to our native homes to See our parents once more as we have been So long from them.— finis."

— SERGEANT JOHN ORDWAY, SEPTEMBER 23, 1806

The Corps of Discovery had traveled 7,689 miles from St. Louis to the Pacific Ocean and back again. They were gone for two years, four months, and nine days, which was twice as long as expected. With the explorers far overdue, the imaginations of those waiting for them in St. Louis and Washington, D.C., feared the men had been lost, having met a terrible fate somewhere in the vast Louisiana Territory. It must have seemed like the raising of Lazarus when those log dugouts, paddles sparkling between deep strokes, rounded the bend and came wonderfully into view.

Index of Paintings

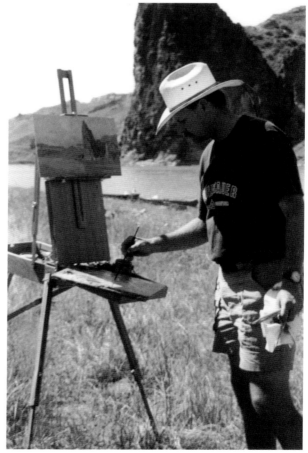

CHARLES FRITZ PAINTING AT CITADEL ROCK ON THE UPPER MISSOURI RIVER IN MONTANA.

About the Author

Charles Fritz's paintings are an honest approach to the world around him—depicting the landscape, life, and history of the Rocky Mountain region. In explaining his style, he describes himself as an outdoor artist, preferring to paint on location—a strenuous and time-honored approach to the changing moods of nature. He has traveled extensively throughout the United States and Europe in order to study the paintings and working techniques of artists whose work he admires. Working in the tradition of such groups as the California Impressionists, the Pennsylvania School, the Russian Itinerants, and the great Western artists and illustrators of the first half of the twentieth century, he defines himself as a Western representational painter.

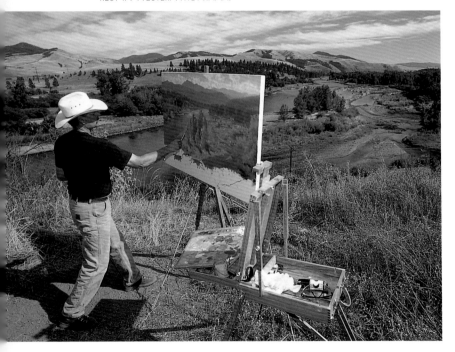

CHARLES FRITZ PAINTING NEAR TRAVELERS' REST IN WESTERN MONTANA.

His paintings, noted for their accuracy, are the product of comprehensive research. Subject matter, composition, design, technique, and surface texture are all areas of particular interest to Fritz.

An important aspect of Fritz's work is interpreting the landscape as he finds it, painting it true to the conditions and characteristics of the location on that particular day. For him, each place is imbued with its own spirit and atmosphere. Working on location and directly from life, he pursues this objective, producing paintings that, like their subjects, each have an inherent uniqueness.

Born in 1955, Charles Fritz grew up in Mason City, Iowa, studying history and education at Iowa State University in Ames. He left teaching to pursue art and has worked exclusively as a professional painter for the last thirty years. His move to Montana in 1980 strengthened his interest in the

history of the Great Plains and the West, which is apparent in the evolution of his work. Today he paints his historical subjects in vast, luminous landscapes. He resides in Billings, Montana, with his wife, Joan, and their sons, Isaac and Erik.

During the Lewis and Clark Expedition Bicentennial of 2003 to 2006, his exhibition of seventy-two paintings—the seed collection to this, the complete works—traveled nationally to seven museums: the Montana Museum of Art and Culture, Missoula, Montana; the Oregon Historical Society, Portland; the National Cowboy and Western Heritage Museum, Oklahoma City; the C.M. Russell Museum, Great Falls, Montana; the Booth Western Art Museum, Cartersville, Georgia; the Yellowstone Art Museum, Billings, Montana; and the MacNider Art Museum, Mason City, Iowa.

In 2009 the Buffalo Bill Historical Center in Cody, Wyoming, hosted the premier exhibition of the complete collection, "An Artist with the Corps of Discovery: One-Hundred Paintings Illustrating the Journals of Lewis and Clark."

Fritz's paintings can be found in private, corporate, and public art collections. He has won many awards and has been honored to have his paintings placed into the permanent collections of the C.M. Russell Museum, Great Falls, Montana; the Denver Art Museum, Colorado; the MacNider Art Museum, Mason City, Iowa; the Buffalo Bill Historical Center, Cody, Wyoming; and the Rahr-West Museum, Manitowoc, Wisconsin.

His work has been included in many museum exhibitions across the country, including the Prix de West Exhibition, National Cowboy and Western Heritage Museum, Oklahoma City, Oklahoma; Salmagundi Club, New York; Albuquerque Museum, New Mexico; Artists of America Exhibition, Denver, Colorado; the Gilcrease Museum, Tulsa, Oklahoma; Great American Masters Exhibition, Cincinnati, Ohio; and the National Museum of Wildlife Art, Jackson, Wyoming.

Fritz is listed in *Who's Who in the American West* and *Who's Who in America.* His work has been featured in many magazines and periodicals and is included in Donald Hagerty's books *Leading the West: One Hundred Contemporary Painters and Sculptors* and *Canyon de Chelly: 100 Years of Painting and Photography.*

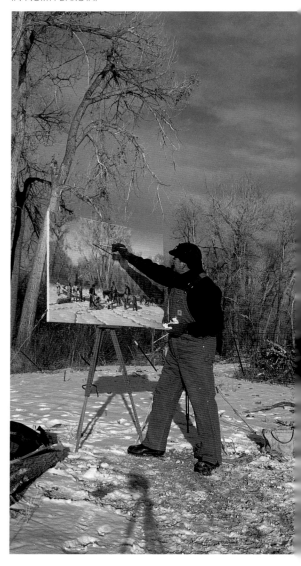

CHARLES FRITZ PAINTING AT FORT MANDAN IN NORTH DAKOTA.

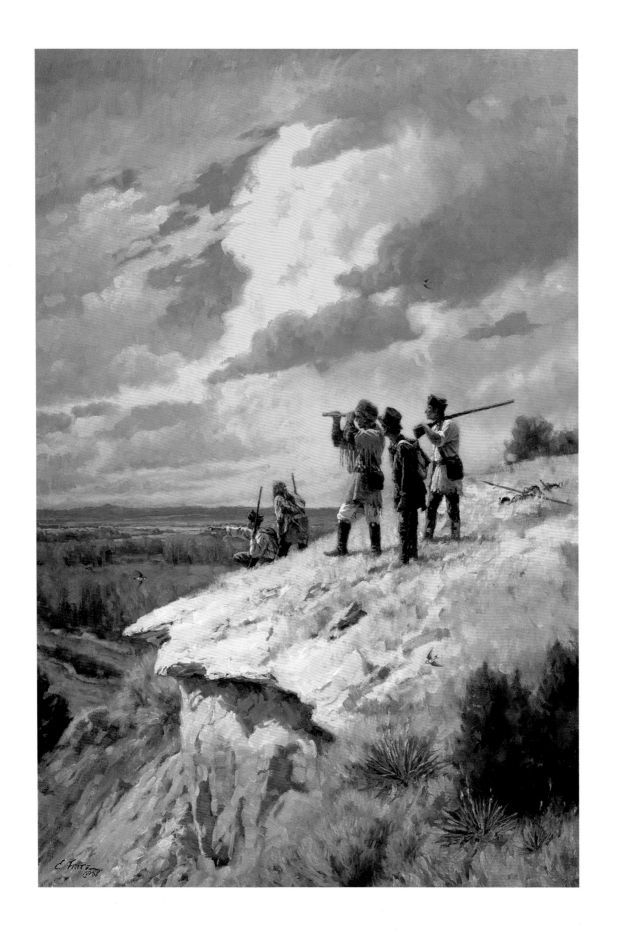

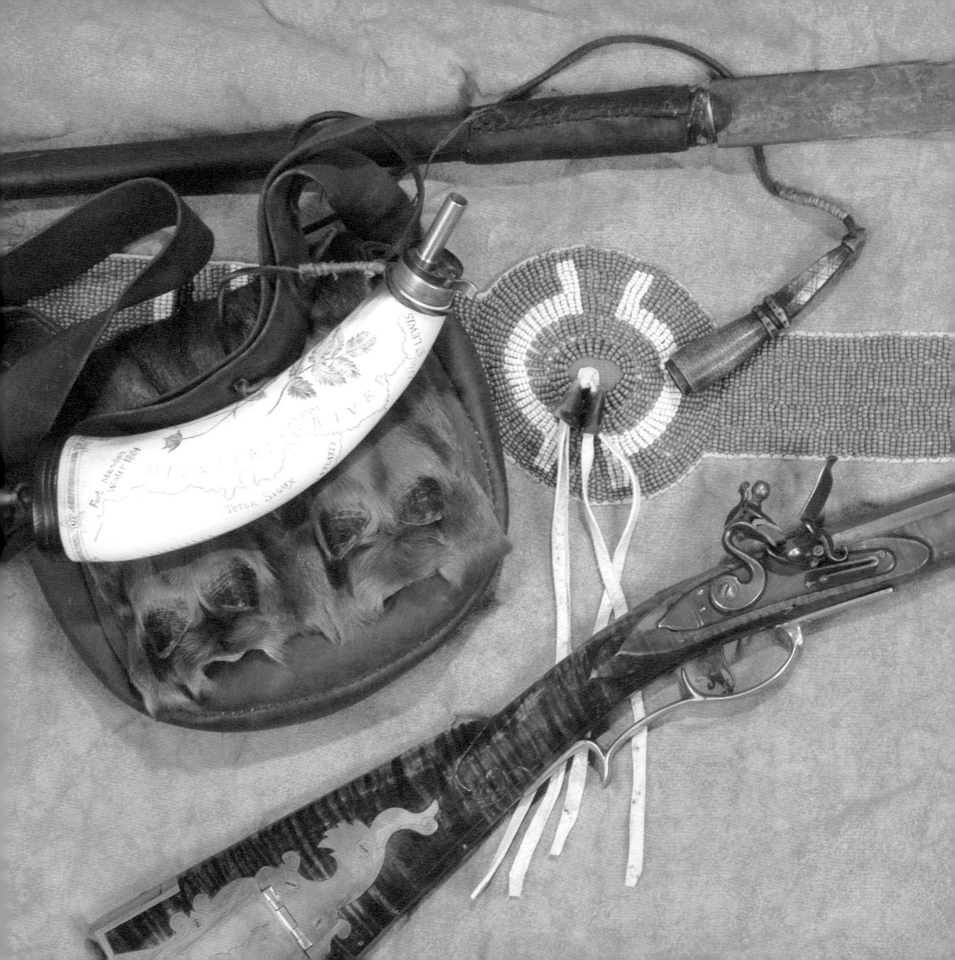